the photographer's
guide to Montreal
& Quebec City

Where to Find Perfect Shots and How to Take Them

Steven Howell

D1290785

THE COUNTRYMAN PRESS
WOODSTOCK, VERMONT

ISBN 978-0-88150-850-5

Cover photos by Steven Howell
Interior photographs by the author unless otherwise specified
Maps by Paul Woodward, © The Countryman Press
Book design and composition by Susan Livingston

Published by The Countryman Press,
P.O. Box 748, Woodstock, VT 05091
Distributed by W. W. Norton & Company, Inc.,
500 Fifth Avenue, New York, NY 10110

Printed in Malaysia

10 9 8 7 6 5 4 3 2 1

Frontispiece: *Ste. Anne de Beaupré Shrine*
Right: *Artillery Park costumed characters in Quebec City*

Acknowledgments

Special thanks goes to: Lévi Bérubé—for just plain putting up with me when deadline looms!

Claude Chiasson, Derrick Isaac, and Jill Craig for their photographic and editorial suggestions.

Countryman Press friends and associates, including Kermit Hummel, Lisa Sacks, Courtney Andree, Kim Grant, and Bill Bowers.

Quebec City Tourism, Sépaq, VIA Rail, Delta Quebec City Hotel.

And to Roland Laliberté, who showed me a few new places in the Quebec City area—Merci beaucoup!

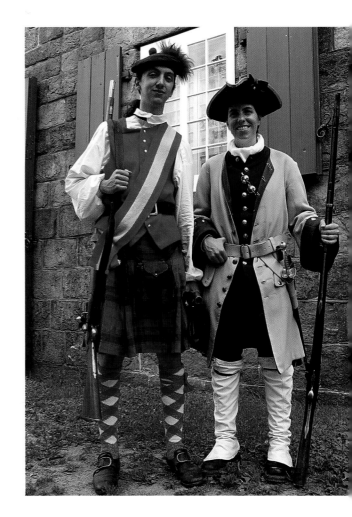

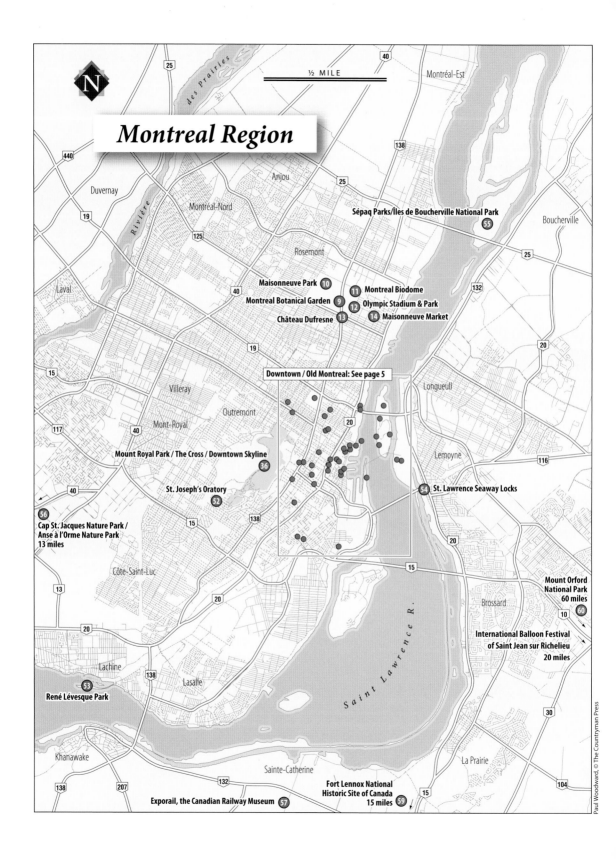

Montreal Region

½ MILE

N

Montréal-Est

Boucherville

Sépaq Parks/Îles de Boucherville National Park 55

Duvernay

Montréal-Nord

Anjou

Rosemont

Laval

Maisonneuve Park 10

Montreal Biodome 11

Montreal Botanical Garden 9

Olympic Stadium & Park 12

Château Dufresne 13

Maisonneuve Market 14

Downtown / Old Montreal: See page 5

Villeray

Longueuil

Outremont

Mont-Royal

Lemoyne

Mount Royal Park / The Cross / Downtown Skyline 36

St. Joseph's Oratory 52

St. Lawrence Seaway Locks 54

Cap St. Jacques Nature Park / Anse à l'Orme Nature Park 56
13 miles

Côte-Saint-Luc

Mount Orford National Park 60
60 miles

Brossard

International Balloon Festival of Saint Jean sur Richelieu 59
20 miles

Lachine

Lasalle

René Lévesque Park 53

Saint Lawrence R.

Khanawake

Sainte-Catherine

La Prairie

Exporail, the Canadian Railway Museum 57

Fort Lennox National Historic Site of Canada 59
15 miles

des Prairies

Rivière

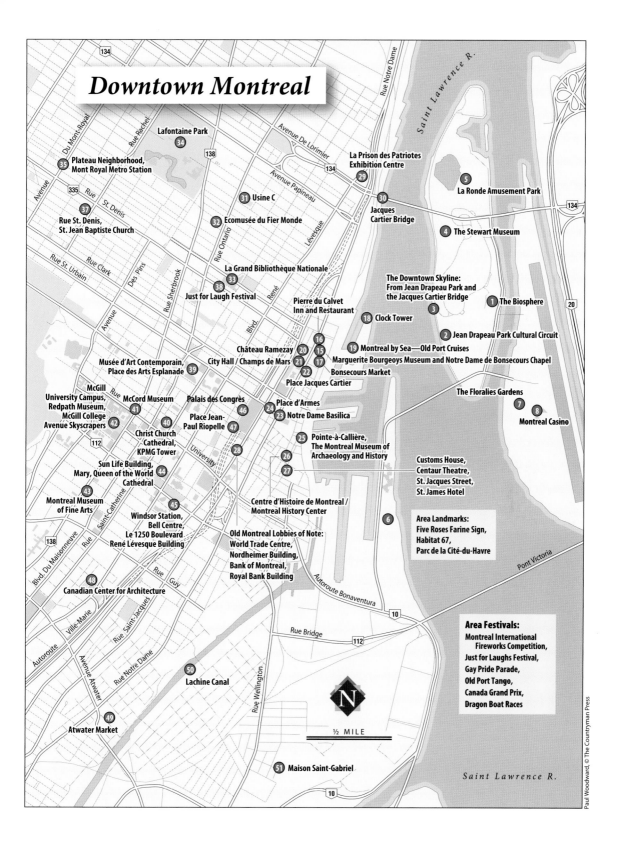

Downtown Montreal

Lafontaine Park (34)

(35) Plateau Neighborhood, Mont Royal Metro Station

(37) Rue St. Denis, St. Jean Baptiste Church

(31) Usine C

(32) Ecomusée du Fier Monde

La Grand Bibliothèque Nationale

(33) (38) Just for Laugh Festival

Pierre du Calvet Inn and Restaurant

(18) Clock Tower

La Prison des Patriotes Exhibition Centre (29)

(30) Jacques Cartier Bridge

(5) La Ronde Amusement Park

(4) The Stewart Museum

The Downtown Skyline: From Jean Drapeau Park and the Jacques Cartier Bridge

(3)

(1) The Biosphere

(2) Jean Drapeau Park Cultural Circuit

Château Ramezay (20) (16)
City Hall / Champs de Mars (21) (15)
(22) (17)
Place Jacques Cartier

(19) Montreal by Sea—Old Port Cruises

Marguerite Bourgeoys Museum and Notre Dame de Bonsecours Chapel

Bonsecours Market

Musée d'Art Contemporain, Place des Arts Esplanade (39)

McGill University Campus, Redpath Museum, McGill College Avenue Skyscrapers (42)

McCord Museum (41)

Palais des Congrès (46)

Place Jean-Paul Riopelle (47)

(40) Christ Church Cathedral, KPMG Tower

Place d'Armes

(24) (23) Notre Dame Basilica

The Floralies Gardens

(7) (8) Montreal Casino

(28)

(25) Pointe-à-Callière, The Montreal Museum of Archaeology and History

(26)

(27)

Customs House, Centaur Theatre, St. Jacques Street, St. James Hotel

Sun Life Building, Mary, Queen of the World Cathedral (44)

(43) Montreal Museum of Fine Arts

(45) Windsor Station, Bell Centre, Le 1250 Boulevard René Lévesque Building

Centre d'Histoire de Montreal / Montreal History Center

Old Montreal Lobbies of Note: World Trade Centre, Nordheimer Building, Bank of Montreal, Royal Bank Building

(6) Area Landmarks: Five Roses Farine Sign, Habitat 67, Parc de la Cité-du-Havre

(48) Canadian Center for Architecture

(50) Lachine Canal

N

½ MILE

Area Festivals:
Montreal International Fireworks Competition,
Just for Laughs Festival,
Gay Pride Parade,
Old Port Tango,
Canada Grand Prix,
Dragon Boat Races

(49) Atwater Market

(51) Maison Saint-Gabriel

Saint Lawrence R.

Paul Woodward, © The Countryman Press

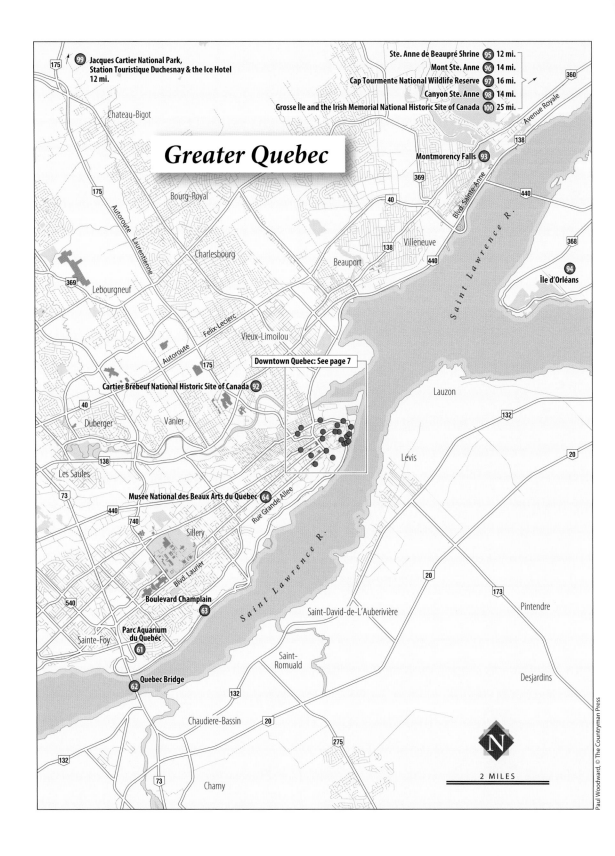

Greater Quebec

99 Jacques Cartier National Park,
Station Touristique Duchesnay & the Ice Hotel
12 mi.

Ste. Anne de Beaupré Shrine 95 12 mi.
Mont Ste. Anne 96 14 mi.
Cap Tourmente National Wildlife Reserve 97 16 mi.
Canyon Ste. Anne 98 14 mi.
Grosse Île and the Irish Memorial National Historic Site of Canada 100 25 mi.

Chateau-Bigot

Bourg-Royal

Charlesbourg

Lebourgneuf

Montmorency Falls 93

Villeneuve

Beauport

Île d'Orléans 94

Autoroute Laurentienne

Felix-Leclerc

Vieux-Limoilou

Autoroute

Cartier Brébeuf National Historic Site of Canada 92

Vanier

Duberger

Les Saules

Downtown Quebec: See page 7

Lauzon

Lévis

Musée National des Beaux Arts du Quebec 64

Rue Grande Allee

Sillery

Blvd. Laurier

Boulevard Champlain 63

Parc Aquarium du Quebéc 61

Sainte-Foy

Quebec Bridge 62

Chaudiere-Bassin

Chamy

Saint Lawrence R.

Saint-David-de-L'Auberivière

Saint-Romuald

Pintendre

Desjardins

Blvd. Sainte-Anne

Avenue Royale

Saint Lawrence R.

N

2 MILES

Paul Woodward, © The Countryman Press

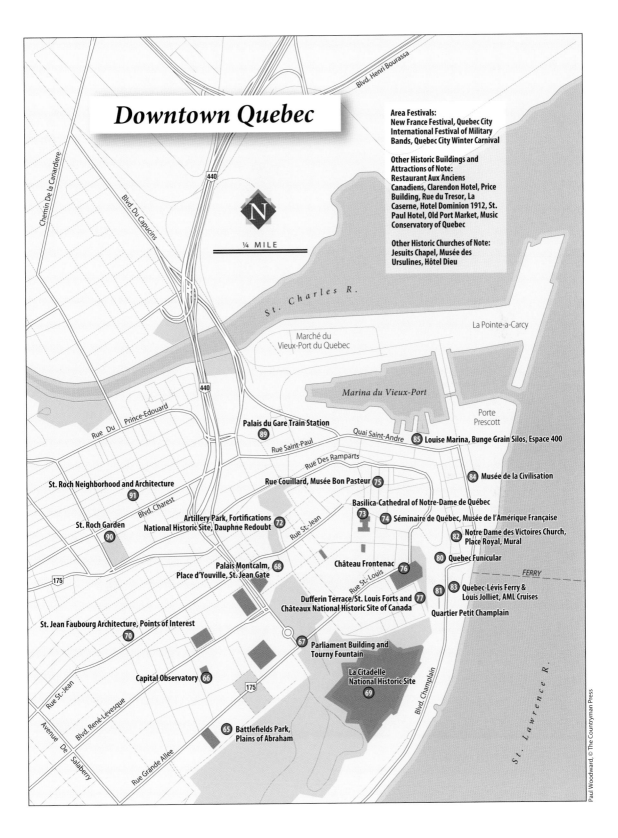

Downtown Quebec

Area Festivals:
New France Festival, Quebec City
International Festival of Military
Bands, Quebec City Winter Carnival

Other Historic Buildings and
Attractions of Note:
Restaurant Aux Anciens
Canadiens, Clarendon Hotel, Price
Building, Rue du Tresor, La
Caserne, Hotel Dominion 1912, St.
Paul Hotel, Old Port Market, Music
Conservatory of Quebec

Other Historic Churches of Note:
Jesuits Chapel, Musée des
Ursulines, Hôtel Dieu

N

¼ MILE

Blvd. Henri Bourassa

440

Chemin De la Canardière

Blvd. Du Capucins

St. Charles R.

La Pointe-a-Carcy

Marché du
Vieux-Port du Quebec

Marina du Vieux-Port

Porte
Prescott

440

Rue Du Prince-Edouard

Palais du Gare Train Station
89

Rue Saint-Paul

Quai Saint-Andre

85 Louise Marina, Bunge Grain Silos, Espace 400

Rue Des Ramparts

84 Musée de la Civilisation

St. Roch Neighborhood and Architecture
91

Rue Couillard, Musée Bon Pasteur 75

Basilica-Cathedral of Notre-Dame de Québec

Blvd. Charest

73

74 Séminaire de Québec, Musée de l'Amérique Française

Artillery Park, Fortifications
National Historic Site, Dauphne Redoubt 72

St. Roch Garden
90

Rue St-Jean

82 Notre Dame des Victoires Church,
Place Royal, Mural

Palais Montcalm, 68
Place d'Youville, St. Jean Gate

Château Frontenac
76

80 Quebec Funicular

FERRY

175

Rue St-Louis

81 83 Quebec-Lévis Ferry &
Louis Jolliet, AML Cruises

Dufferin Terrace/St. Louis Forts and 77
Châteaux National Historic Site of Canada

Quartier Petit Champlain

St. Jean Faubourg Architecture, Points of Interest
70

67 Parliament Building and
Tourny Fountain

Rue St-Jean

Capital Observatory 66

175

La Citadelle
National Historic Site
69

Blvd. Champlain

Blvd. René-Levesque

Avenue De Salaberry

65 Battlefields Park,
Plains of Abraham

Rue Grande Allee

St. Lawrence R.

Paul Woodward, © The Countryman Press

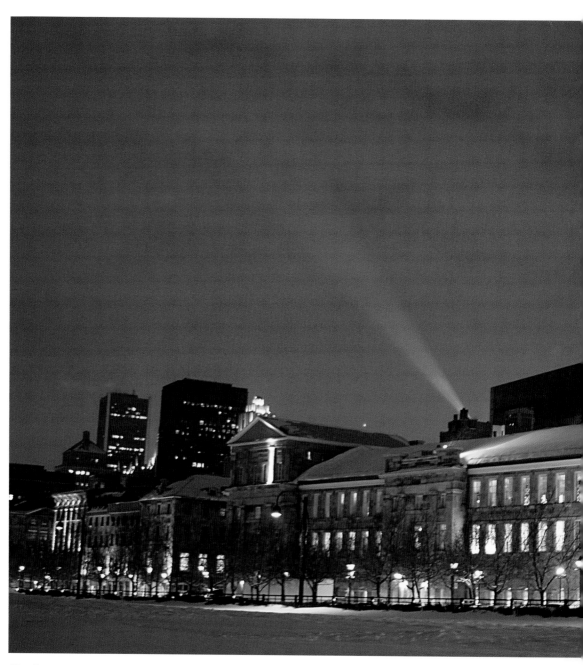

Marché Bonsecours in winter

Contents

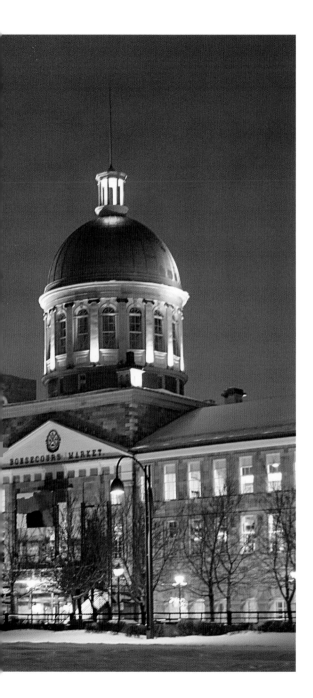

Quebec City

Mount Royal winter scene

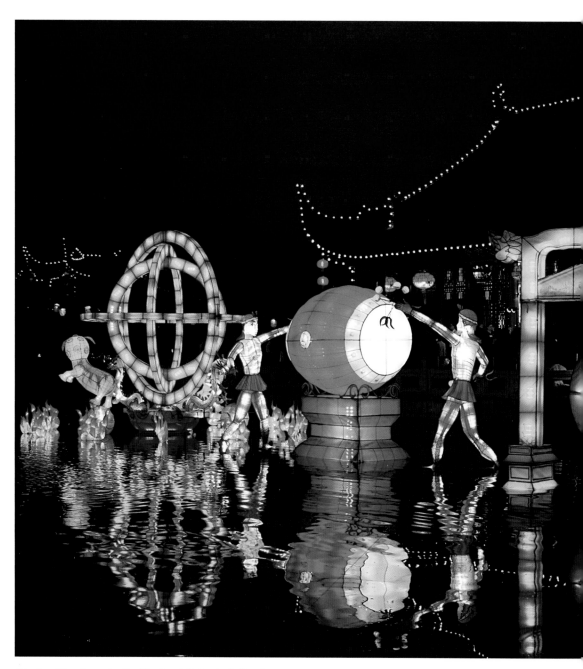

Magic of Lanterns in the Montreal Botanical Garden

Introduction

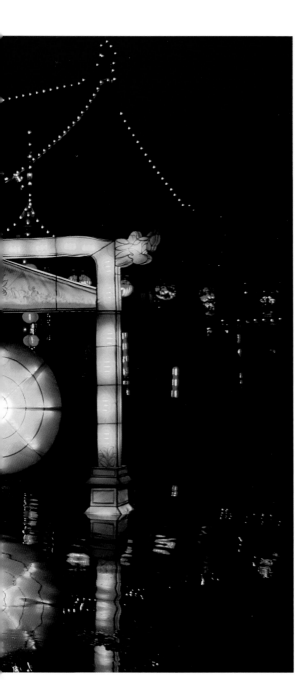

We say cheese! They say *sourire!* Same happy result.

Modern city skylines, bustling urban life, and New France charm combine to take center frame when photographing Montreal and Quebec City.

Two of the oldest settled regions in North America, Montreal and Quebec City offer a variety of photographic subjects both old and new. Montreal defines vibrant city life with a population that truly knows the meaning of *joie de vivre,* while Quebec City brims with history as it celebrated its 400th anniversary in 2008 in a big way.

Both cities enjoy UNESCO designation. Quebec City was named a UNESCO World Heritage Site in 1985, and that means iconic 17th-century church steeples bathed against a bright blue sky, or a horse-drawn carriage parked in front of the famed Château Frontenac —said to be the most photographed hotel in the world. In 2006, UNESCO selected Montreal as a City of Design, for its modern architecture with a touch of urban class.

While a variety of architectural subjects are easy to find, serene nature shots and sumptuous landscapes aren't far from big-city life, either. In Montreal, the Botanical Garden and the Biodome offer unique flora and urban-style fauna. While near Quebec City, Île d'Orléans offers a pastoral farm setting less than a 20-minute drive from downtown. And if you've got the gumption and the long johns to endure some cold weather, winter scenes abound as well. The photo subjects here include Mount Royal Park winter revelers sledding down a hillside or gutsy ice climbers tackling the frozen Montmorency Falls. These two examples introduce a photographic rule of thumb to

Lower Town Quebec City skyline

remember—don't forget to add people to the frame, no matter the time of year.

Annual events bring out the best in both cities and are worthy of photographing. In Montreal, the subjects of note include rowers competing in a colorful dragon boat race to romantic couples dancing an Old Port tango. In Quebec City, capture energetic huskies pulling a dogsled during the famed Winter Carnival or New France revelers dressed in authentic costume during festival time every August. In essence, you'll be able to take unique photographs that you wouldn't be able to capture anywhere else in the world.

This book offers 100 of the best photo ops in town—and then some. I'll not only suggest my personal favorites when it comes to photography, I'll also recommend a few worthy hotels and restaurants (I discovered many great places in both cities, from freelancing for the past 14 years, as well as writing and photographing my first book, *Great Destinations: Montreal & Quebec City*).

After all the must-take shots, you will no doubt meet some friendly folks in Montreal and Quebec City. And that's cause for a simple family-style snapshot. So gather your new-found francophone friends and smile for the camera—*sourire!* These may be your favorite shots of all.

How to Use This Book

This book is geared toward photographers of all levels. Whether you're a point-and-shoot beginner, an avid amateur with your first digital SLR, or a serious pro who rises to the challenge of adding unique flair and perspective to a subject that's been photographed many times before—I've got some great suggestions for you all.

I've also listed some basic photo techniques—the ones I personally use most often. To the seasoned pro: while you may not learn anything new as far as technique is concerned, I will offer pertinent information such as lighting, best times of day to shoot, and admission fees for the listings. A bit of history about each subject is also included.

Most of the suggestions can be shot year-round. Select festivals are also included in case you're in town and want to shoot a specific event. In addition, the book is not presented alphabetically, but geographically by neighborhood and area. This way you can plan your trip accordingly.

Each chapter's star rankings may seem repetitive due to the proximity of each neighborhood. I kept the following in mind when I ranked each chapter.

High tourist season in Montreal and Quebec City runs from mid-May to mid-October. I'm guessing that's when you'll probably be in town, so I concentrated on activities and photo subjects that take place during that time frame. While winter shots are unique, not all attractions, such as area parks, are open—and this is the reason for a lower star ranking.

I love spring, for many reasons, when photographing Montreal and Quebec City. Again, while area parks may not be open because of the spring thaw, also known as mud season, I specifically enjoy photographing city architecture when leaf buds are just about to bloom on the local trees—you simply get to see more of a particular building, and the trees don't look so bare. In addition, you can capture some intense blue skies during these seasons. Spring ranks from moderate to high on the star rankings, more for May and early June than for March and April.

Summer offers lots to do and places to see, but unique lighting challenges. There's nothing like a dramatic summer storm backdrop—just don't be the tallest point in an open field come lightning time! Finally, the autumn landscape lends itself to fewer tourists (on the streets and in parks and restaurants) and dramatic fall foliage to boot. Summer and fall star rankings rate consistently high.

That said, no matter the season, get ready to be photographically inspired.

Ste-Famille Church, Île d'Orléans

How I Photograph Montreal and Quebec City: Photographic Techniques

Buying a Digital Camera: Megapixels—Is Bigger Better?

In the market for a new camera? Taking better shots doesn't necessarily mean a bigger, better camera.

You don't have to buy the latest and greatest gear every time something new comes on the market—although the technology seems to improve monthly. Instead, consider the home of your photograph—this may help you decide what type of camera to buy.

Are you using your shots for a newspaper article, an art exhibition, or a stock photo agency? Each has different submission requirements. See what they require first. If you just want to share your photos with friends, I suggest using what you've got. That said, if you use a point-and-shoot camera and are considering making the leap to a digital SLR—go for it. You won't believe the technology, speed, and results, in addition to the currently lower prices of quality equipment.

Welcome to the Digital Age

Lesson number one: learn your camera. Congratulations on entering the photographic digital age. And congratulations on purchasing your new camera. Now read the instructions. You don't have to read that 100-page instruction booklet all at once, but your digital camera can do some amazing things. Just take it one shot at a time.

Lesson number two: get yourself good photo processing software, i.e., Adobe Photoshop. Once again, it may seem a daunting tool at first, but learn one new technique at a time.

Not only can your camera do some amazing things, the accompanying software can help clean up a variety of mistakes that you may have made in the field.

Resolution

High-res or RAW—what resolution setting is best for you? Once again it depends on for what purpose you're using the photo—as well as how much room you have on your computer.

RAW files capture images in their purest digital form. The saved file lets you alter the image in many different ways after you've taken the initial shot. But RAW images take up a lot of space. If you need to do a lot of post-processing to adjust the photo for any number of reasons—such as lighting, exposure, and contrast—or are using the photos in a professional way and have the room on your hard drive—RAW is the way to go. That said, when I submit photos for my local newspaper assignments, a jpeg is all that's required.

If you just want to save a shot for your own photo scrapbook, I think a large-file jpeg is fine. In addition, some cameras, like the Canon line, take a combo—a jpeg and a RAW, as well as a jpeg and a smaller RAW version. Finding the home for your photo first will help you decide what res is best for you.

Equipment That Comes in Handy and Proper Camera Care

I love my tripod but I don't use it all the time. Often I like to travel in Montreal by bicycle, so I bring my camera in its backpack-style case as

Cap Tourmente storm

well as a notebook and pen (the reporter in me). But if I'm shooting a specific shot planned in advance, and especially at dawn, at dusk, or at night, I always bring my tripod. I sometimes use an automatic shutter release. The camera can still shake during long-exposure night shots simply from manually pressing the shutter, even when it's mounted to a tripod. Don't have a tripod handy when you need one? Use what you've got—a fence, a lamppost, your body—even a friend's head!

To clean the lens, I almost always go dry, using a micro cloth made specifically for that purpose. Occasionally an alcohol-based cleaner will rid the lens of accumulated dirt or water spray spots. Don't use your clothes to clean your lens, as there's probably sweat and dirt on that T-shirt of yours. And change your lenses with the camera facing down, in the cleanest environment you can find—you don't want the digital sensor getting dirty. If it does get dirty, save this cleaning job for the professionals.

As for filters: sometimes I use them, sometimes I don't—it's a personal preference. A polarizing filter can help reduce glare. A lens hood also helps prevent glare.

A backup battery and one or two extra flash cards come in handy. I prefer high-quality flash cards only (i.e., SanDisk Extreme).

Baby, It's Cold Outside: Protecting Your Camera from the Elements

I haven't had many problems with my camera in the cold, but I'm not usually outdoors for hours at a time in the severest of cold weather when taking winter shots. That said, Canadian winters can be harsh, and it is important to protect your fingers. Invest in a good pair of half gloves that allow you to maneuver your camera's controls and then quickly cover up bare fingers with a warm pair of mittens.

Embrace the weather as well. In Montreal and Quebec City, I have the luxury of shooting and returning to the scene of the shot if I don't

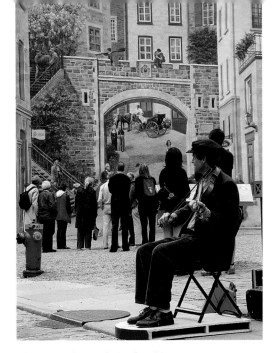

Place Royal mural, Quebec City

like what I got the first time around. You, on the other hand, are probably on vacation and in town for a limited amount of time. That means a variety of unpredictable weather. What to do? Take a tip from the locals and go with the flow. Try a different perspective or zoom in on an architectural detail if you don't want a washed-out sky in your shot. Blue skies are indeed beautiful, but a cloudy day can balance out lighting—especially along those narrow, winding streets of Old Quebec. And never underestimate the power of a puffy cloud!

Before You Shoot—Things to Consider:

Rules of Composition—The Rule of Thirds: Line, Shape, Balance, and Mood

First ask yourself: what am I shooting? What is the subject? Pick a subject and then place it properly. Here's how.

Remember tic-tac-toe? Think of your photo as a rectangular tic-tac-toe board with nine boxes—like a grid. And it doesn't matter if the shot is horizontal or vertical. In essence, you don't want your subject completely centered. Instead, you generally want your subject to fall near any of the corners of the center square. This offers balance and proper composition. That said, break the rules, get really close-up, completely center something, and see what happens—sometimes that works, too!

Use lines and perspective to help draw your eye to the "back" of a photo, i.e., a fence, a row of houses, a street. When you change your angle, you change your perspective. Move around and vary each shot.

Photographs without borders: take just a part of something. Capture a close-up of something big and let your imagination fill out the frame—it will.

A balanced (photo) diet: add something in the foreground to balance out the background, such as cyclist on a bike path against a city skyline.

Create a mood. Play with your aperture and focus on one particular subject while blurring out the rest of the photo. And don't be so quick with the flash—use existing lighting whenever you can.

Best of all: rely upon your intuition. Take a break from the automatic settings and tell the camera what to do—and not the other way around.

Visualization and the Decisive Moment

Think before you shoot. Timing is everything. For example, shooting fireworks? Anticipate the explosion. A building often looks nice. A building with a passerby can sometimes look better. In essence, slow down and take some time to take a shot.

Survival Tips on Clichéd Subjects

There are plenty of photo ops out there—even if it seems a subject has been shot to death. So try to be creative and change your point of view

and perspective on life. Shooting children or animals? Come down to their level. Or try changing the time of day you shoot a landmark. It may mean waking up much earlier than your normal time, but you may get the shot that people envy. I love dawn and dusk because a little mood lighting can go a long way. And try zooming in for architectural detail instead of taking the whole shot of that famed landmark. For example, shoot the Château Frontenac not from the exterior, but take a tour and capture the iconic roof turrets from the inside out. Play, play, play with your camera. Brainstorm, be creative, and experiment. And most of all, have fun—you may be delightfully surprised with the result.

After You Shoot—Digital Post-Op Surgery for Photos: Exposure Adjustments

I can't tell you how many times I thought I had the proper light settings and composition when capturing that perfect image—even with viewing the LCD screen just after taking the shot. (Hey, on a sunny day that LCD screen isn't always so easy to see—especially if you forget your glasses—guilty!)

So if you've underexposed or overexposed a photo—we all do it—don't fret. In the field, adjusting your F-stops will help balance the lighting. For example, during Montreal and Quebec City winters, snow shots sometimes appear dingy and gray. The solution: a lower F-stop by one or two should adjust the lighting to make the snow accurately white. And if you didn't get the proper exposure settings out in the field, all is not lost. Play with Photoshop tools such as Curves & Levels to properly adjust exposure problems.

Finally, crop away to eliminate the likes of an errant power line, ugly smokestack, or unseen garbage can. Improve your photos by embracing the software technology and the things you can do after you've taken the shot.

Photo Releases

Your eye for the public may legally be in the public eye as long as you get permission. If you take a photo of someone—even in a public space—get their written permission to reproduce their image if it's to be used for commercial purposes. It's a good idea to carry a few photo releases with you at all times, just in case. In addition, be careful of corporate logos that find their way into your shots if you're using the photo for commercial purposes.

Keeping Track of What You Take

It takes some diligence to download and properly label your photographs. And they do add up on those little flash cards—hundreds of photos at a time. Label your folders by date, place, or subject—whichever works for you.

Practice and Patience

I take many photos when in the field. I admit I sometimes take too many photos of almost the same thing. But what I try to do with each new shot is adjust my settings, be it the F-stop, shutter speed, or ISO. Why? That good result from one shot can sometimes ensure a better result on the next shot. Automatic shooting is okay at times, especially to see what the camera is reading. But so are manual settings. As I mentioned before, learn your camera and have fun experimenting. And don't be so quick to delete while on the road. Instead, embrace your photographic accidents; you may be surprised at the result.

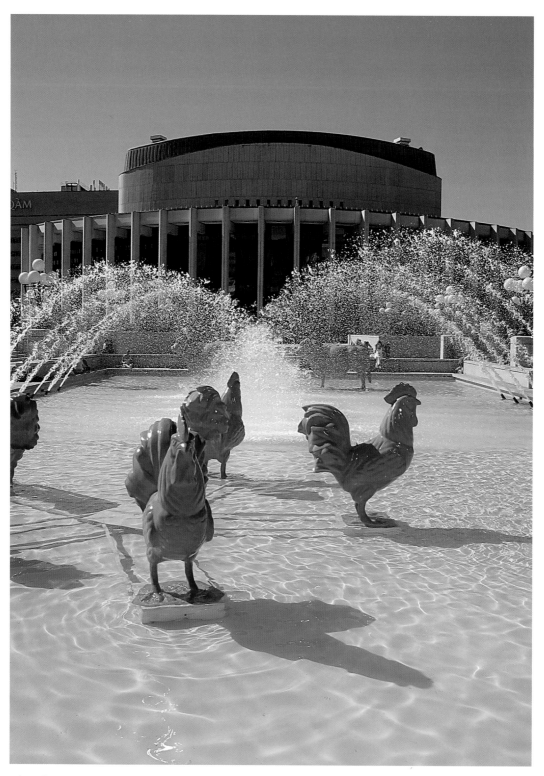

Place des Arts Esplanade

I. Jean Drapeau Park

SPRING ★ ★ ★ SUMMER ★ ★ ★ ★ FALL ★ ★ ★ ★ WINTER ★

General Description: Jean Drapeau Park is Montreal's all-season playground, both indoors (Montreal Casino) and out (La Ronde Amusement Park). Visitors can best explore the space by bike or on foot, but there is a lot of ground to cover—about 660 acres—on the two islands that comprise the park, Île Ste. Hélène and Île Notre-Dame. The extensive Web site offers maps and a calendar of events. For information call 514-872-6120 or visit www.parcjeandrapeau.com.

Directions:

By Metro: Take the Yellow Line from Metro station Berri/UQAM to Metro station Jean Drapeau. The Jean Drapeau station is within close walking distance of the Biosphere and not too far from the Stewart Museum and downtown skyline views. A bus transfer takes you to La Ronde or the Montreal Casino.

By car: Take the Jacques Cartier Bridge and exit halfway across the bridge for access to Stewart Museum, the Biosphere, and La Ronde. From downtown take Autoroute Bonaventure (Autoroute 10) to exit (*sortie*) 1. Follow the signs for the casino.

By bike: Yes, you can ride your bicycle to Jean Drapeau Park. The bike path from the western end of Old Montreal will get you there.

By boat: The St. Lawrence River shuttles—*navettes*—offer seasonal service from the Old Port at the Jacques Cartier Quay. The trip first stops in Longueuil and then Jean Drapeau Park. It costs about $6, and you can bring a bike on board.

Where: Jean Drapeau Park

Noted for: Outdoor public art, downtown skyline views, Expo 67 landmarks, amusement park rides, urban gardens, and groundhogs

Best Time: Spring through fall

Exertion: Minimal to moderate (a lot of walking or biking on mostly level terrain)

Parking: Municipal pay lots are available near the Stewart Museum and inside the Montreal Casino.

Metro Station: Jean Drapeau on the Yellow Line

Sleeps and Eats: Bathrooms and seasonal snack kiosks are located near the Metro station. Expensive amusement park food is available at La Ronde. Nuances Restaurant at the Montreal Casino is one of the best in town.

Sites Included: Montreal Biosphere, Montreal Casino, Habitat 67, La Ronde Amusement Park

Area Tips: While it's a fun event on its own, if you want the park all to yourself, avoid special events like the Osheaga Music Festival, when an additional 20,000 folks show up for a weekend of music.

The Biosphere (1)

Operated by Environment Canada, the Montreal Biosphere is a museum dedicated to the preservation of the St. Lawrence River, the Great Lakes ecosystem, and the world around us. The building, most specifically its geodesic dome, was designed as the American pavilion for Expo 67 by architect Buckminster Fuller. It is one of the most recognizable structures on the Montreal skyline, and perhaps one of the most photographed—whenever I visit, I am by

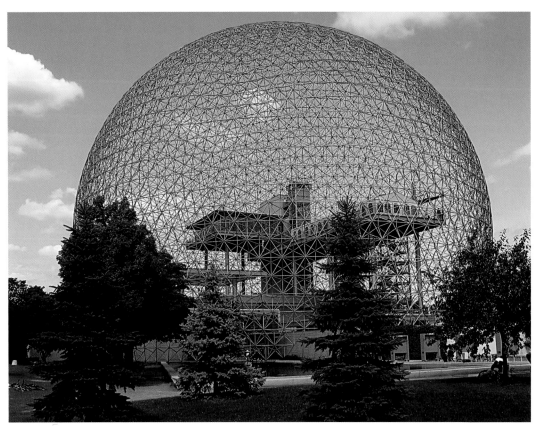

Montreal Biosphere

no means the only one with camera in hand. In fact, I've even seen models dressed in colorful outfits standing knee-deep in the main entrance reflecting pool having their photos taken for a professional picture shoot.

There are many ways to capture the dome. A wide-angle lens will let you squeeze most of the dome into a frame from up close. Pine trees and a marsh add foreground greenery to the scenery, but I find a blue sky and a few clouds work best for this one. On the best days, the setting summer sun accentuates the dome perfectly. You can access the dome interior without paying for the museum visit. This up-close interior perspective offers playful geometric patterns and, if you're lucky, you'll be able to add the silhouette of a blackbird using the dome as a giant perch. You'll have fun shooting this one.

> On Île Ste-Hélène.
> Call 514-283-5000.
> Visit www.biosphere.ec.gc.ca.
> Price: Outdoor access is free.
> A museum visit costs about $10 for adults.

Jean Drapeau Park Cultural Circuit (2)

The Jean Drapeau Park Cultural Circuit offers 11 large sculptures that adorn both islands. Think of it as an outdoor artistic treasure hunt. The most famous is Alexander Calder's *Man*, which was built for Expo 67. *Man* is located a

short walk from the Metro station, and its locale also offers great views of the Montreal city skyline. While a good thing, there are many recycle and trash bins in the sculpture's vicinity, which tend to get in the shot. Nonetheless, you can opt for an abstract close-up.

The on-site information kiosk near the Metro entrance offers free maps that mark the location of each sculpture.

The Downtown Skyline: From Jean Drapeau Park and the Jacques Cartier Bridge (3)

Jean Drapeau Park makes a great vantage point from which to capture Montreal's skyline. The Old Port, the downtown core of buildings, and even Mount Royal Park and its iconic cross are all visible.

One of the better spots is the belvedere where Calder's *Man* is located. From the belvedere, a walking path stretches to the river shuttle dock a short walk away (turn right when facing the city from the sculpture). The entire path boasts a beautiful view. From this direction, the sun will be at your back and hit the skyline during morning hours. Late afternoon storms and summer sunsets can add a colorful and dramatic sky.

A taller vantage point is accessible from the Lévis Tower, which was built in 1930 and was recently refurbished. It's located a short walk from the Stewart Museum. The tower peaks at 92 feet high and has an indoor, 157-step staircase that leads to the observation deck where

Alexander Calder's Man *sculpture details*

you'll have a 360-degree view of the area. That said, tower access isn't open daily (I found out the hard way). Nonetheless, the tower makes for a nice structural element in your shot.

Finally, if you've got the nerve and aren't afraid of heights, make your way to the pedestrian path on the Jacques Cartier Bridge for a truly spectacular view (more on the bridge is mentioned in the Gay Village chapter). A small landing area is located on the bridge not far from the Stewart Museum parking lot. From the lot it's about a half-mile walk. There are actually two parking lots—P7 and P13—along Chemin du Tour-de-l'Îsle, the island's main thoroughfare, which will leave you close to the bridge.

Be aware of cyclists on the bridge's pedestrian path. In addition, there's a bit of vibration from the bridge's vehicular traffic, so your tripod may be useless. But it is safe. It may sound a bit crazy, but hey, you're a photographer—you'll do anything to get that perfect shot!

The Stewart Museum (4)

Atten-SHUN! The Stewart Museum is housed in an actual fort that dates to the 1820s. The collection highlights some 30,000 objects, including navigational instruments, antique arms, scientific apparatus, archival documents, original maps, and vintage books. Unfortunately, photos are not allowed inside.

In keeping with the fort's military theme, a

Lévis Tower, Jean Drapeau Park

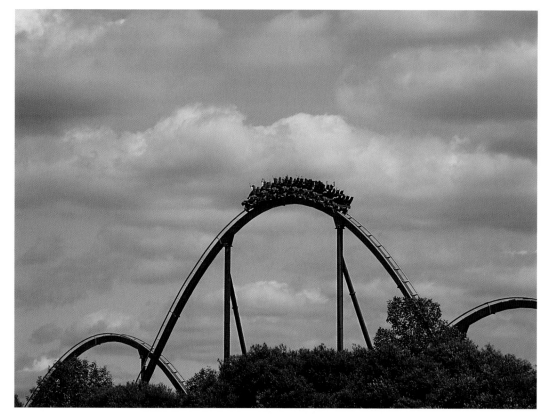

Goliath Roller Coaster at La Ronde Amusement Park

fun photo op is the soldier reenactments. Ongoing activities include a daily noonday gun salute all summer long, and military drills performed by the fort's two resident troops, the soldiers of La Compagnie Franche de la Marine and the Olde 78th Fraser Highlanders. The costumes are as authentic as the smiles.

A word of note: the museum is undergoing extensive renovations until 2010, so access is limited.

On Île Ste. Hélène.
Call 514-861-6701.
Visit www.stewart-museum.org.

La Ronde Amusement Park (5)
One of the more popular summer attractions in town is La Ronde Amusement Park. Quebec families, cliques of school kids, and tourists alike have been making annual summer pilgrimages to La Ronde since its debut during Expo 67. La Ronde is now a Six Flags theme park.

I have included La Ronde for a number of reasons. For one, the shots are fun! In addition, you can really explore fast-action photography with any of the four dozen rides on site. But it's interesting to note that one of my personal favorite photos of La Ronde's Goliath roller coaster wasn't taken from the amusement park, but from aboard the St. Lawrence River shuttle (mentioned in Chapter III, Old Montreal).

As the boat passed the amusement park near where Goliath is located, the coaster hit its zenith—the thrillseekers could almost touch the sky. There was only one way they could

go—and that was DOWN! FAST! The shot told a memorable story because I had indeed experienced the same excitement of La Ronde in the past and knew exactly what was going on in the minds of those strapped-in thrillseekers.

It's a pricey day, but bring a few friends so that you can enjoy some of the rides while someone watches the gear. You can also capture fireworks up close on 10 dates in summer, as Montreal's International Fireworks Competition originates from the park. (You can also shoot the fireworks for free from on or under the Jacques Cartier near the Gay Village.)

On Île Ste. Hélène.
Call 514-397-2000.
Visit www.laronde.com.
Price: About $39 for adults.

Area Landmarks: Five Roses Farine Sign/Habitat 67/Parc de la Cité-du-Havre (6)

These landmarks are grouped together because of their proximity to each other on the way to the Montreal Casino. They are best accessed by car, cab, or bike (the Jean Drapeau Metro station, even with the bus transfer to the casino, is a bit of a walk).

For iconic Montreal industrial architecture, look no further than the Five Roses Farine (flour) silos, and specifically its neon sign—a legendary local landmark in these parts and near and dear to many a Montrealer. Just how long the sign will remain is anybody's guess. There's a place to park—a lot near Autoroute 10 and Avenue Pierre Dupuy—but don't stay there all day, as it's casino property.

Cité du Havre painter

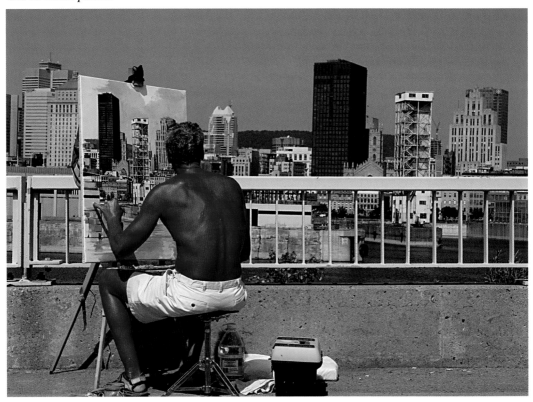

Just down the road along Avenue Pierre Dupuy, you can discover the geometric photographic playfulness of Habitat 67, an apartment building complex introduced during Expo 67. The architectural design resembles room-size building blocks haphazardly piled one atop the other. You can photograph the complex from the front, as you are on public property, but driveway access is for residents only. A word of note: be considerate of the occupants—this is their home. In fact, it's some of the most expensive real estate in town.

Shots of the St. Lawrence River, the Old Port of Montreal waterfront, arriving cruise ships, downtown skyline, and the Jacques Cartier Bridge can be had from the pedestrian bike path that runs all along Avenue Pierre Dupuy across the street from Habitat 67, as well as from Parc de la Cité-du-Havre, a small green space that juts out into the St. Lawrence River. Travel farther along Avenue Pierre Dupuy, cross the Concorde Bridge, and you're at the Montreal Casino.

The Floralies Gardens (7)

The Floralies Gardens and lagoons, built for the Floralies Internationales Horticultural Fair in 1980, boast 60 acres of annuals, perennials, aquatic plants, and majestic willow trees. While the Cultural Circuit sculptures are dispersed throughout the park, the Floralies Gardens is located on Île Notre-Dame near the Casino. However, the garden's centerpiece, the Wallace Fountain, is considered one of the 11 Cultural Circuit sculptures.

If you can't make it to the Botanical Garden and are in the mood to photograph landscaped greenery, this is a good bet. In addition, the still waters of the surrounding lagoons will let you explore shots with tress and flora reflected onto the water. That said, the lagoon shots are available in summer only. Best of all, this visit is free.

Montreal Casino (8)

From nickel slots to high rollers, the Montreal Casino has been a popular tourist attraction since it opened in 1992. The two main buildings are remnants of Expo 67, the futuristic-looking former French pavilion and the box-shaped Quebec pavilion with its reflective gold-mirrored exterior. A reflecting pool near the rear of the French pavilion makes a fun shot, but it's hard to capture all those flags standing at attention at the same time! Unlike Las Vegas, interior shots are not allowed.

On Île Notre-Dame.
Call 514-392-0909.
Visit www.casinos-quebec.com.

Area Festivals: Canadian Grand Prix, Dragon Boat Races

The Canadian Grand Prix will satisfy your need for photographing speed. The cars are Formula 1 class, with drivers from all over the world. The Grand Prix is Montreal's official kick-off to the summer tourist season and one of the city's largest annual tourist draws. It's usually held the second week of June, and a pricey affair at that. Call 514-350-0000, or visit www.grandprix.ca.

A word of note: As of this book's publication date, it was announced that the 2009 edition of the Grand Prix has been canceled (the status of future editions remains uncertain as well). Organizers have pulled this stunt in the past to great public outcry and the promise of new sponsors. Keep checking their Web site for updates, or instead enjoy NASCAR racing events in late summer.

The Dragon Boat Races offer the colorful photographic subject of an ancient Chinese tradition. See if you can capture the spirit of teamwork at its best. The races are held at Olympic Basin the third or fourth weekend of July. Admission is free. Visit www.montreal dragonboat.com.

II. Hochelaga/Maisonneuve/East End

SPRING SUMMER FALL WINTER

General Description: You could spend the day photographing Montreal's Hochelaga/Maisonneuve neighborhood at one place in particular, the Montreal Botanical Garden, one of my personal favorite places to photograph year-round. The area also offers urban wildlife at the nearby Montreal Biodome, while neighborhood architectural gems include Château Dufresne and the Maisonneuve Market.

Directions: By Metro from downtown, take the Green Line in the direction of Honoré-Beaugrand. Two stations service the area: Pie-IX, which is closer to the Botanical Garden and Château Dufresne; and Viau, which leaves you adjacent to the Olympic Stadium and the Biodome entrance plaza as well as Saputo Stadium. A word of note: Maisonneuve Market, the Maisonneuve Public Bath building, and Maisonneuve City Hall are about a half-mile walk or cab ride from Viau Metro station.

By car, take Sherbrooke Street east from downtown.

Guarianthe flower, Montreal Botanical Garden

Where: Montreal's Hochelaga/Maisonneuve neighborhood in the east end of town

Noted for: Urban flora and fauna, iconic Montreal attractions, Beaux-Arts style architecture

Best Time: Spring through fall

Exertion: Minimal (a bit of walking)

Parking: Municipal pay lots are available at the Botanical Garden and Maisonneuve Park. Street parking is available as well (check parking signs for restrictions).

Metro Stations: Pie-IX or Viau

Sleeps and Eats: This is a residential part of town, so accommodations are limited. Premiere Moisson at the Maisonneuve Market offers fresh baked goods, sandwiches, and coffee.

Sites Included: The Montreal Botanical Garden, the Montreal Biodome, Olympic Stadium, Château Dufresne, Maisonneuve Market

Area Tips: Save admission fees when you purchase a Nature Package discount to the Botanical Garden, Biodome, and Olympic Tower Observatory.

Montreal Botanical Garden (9)

There are four seasons of unique and colorful photographic subjects to be found both indoors and out at the Montreal Botanical Garden. This is one of my favorite visits in town with camera in hand. Teacher and botanist Brother Marie Victorin established the garden in 1931, and it has since blossomed into one of the world's premier botanical gardens. The site features 30 thematic gardens outdoors, as well as 10 indoor exhibition greenhouses.

For a splash of winter color, an indoor tour

Botanical Garden close-up

includes a stroll through the Orchids and Aroids, and the Begonias and Gesneriads Conservatories. All the plants are easily marked with their common and Latin species names. Outdoors, a designated birdwatching trail offers a glimpse of winter fauna, and cross-country skiers add subjects in motion across a fresh blanket of snow.

Every year from February to April, some 15,000 butterflies take flight in the main exhibition greenhouse with the annual Butterflies Go Free rite of spring. The butterflies aren't all released at the same time, but there's never a problem in finding a willing winged subject, especially atop a bright pink azalea in full bloom. The butterflies are usually friendlier if you wear bright colors. A word of note: the place gets packed for Montreal school break week and the weekend that coincides with Easter. In addition, protect your camera from the light spray of the overhead watering system inside the likes of the Tropical Rainforests Conservatory.

By May and June, head outdoors to the Leslie-Hancock Garden, where you'll find rhododendrons, azaleas, and heaths in full bloom offering intense and brilliant shades of red, yellow, and orange. Equally impressive is the rose garden, which numbers 10,000 roses strong along winding paths. Also in summer, flowering crabapples and the Japanese pavilion add a moment of Zen to your photos. During September and October, the Magic of Lanterns—the garden's most popular event—promises an illuminating experience as some 700 imported colorful silk lanterns light up the Chinese Garden during Montreal's crisp autumn nights. And any time of year, the Olympic Tower makes a dramatic backdrop in many corners of the garden.

The on-site Tree House, a small museum space devoted to trees—located near the arboretum—often displays photographic exhibitions that in the past have explored the garden through its eight decades of history, as well as the garden at night.

A macro lens definitely comes in handy during your botanical garden visit—there are lots of close-ups to be had. Tripods are allowed on the outdoor grounds all year long, but prohibited inside the greenhouses.

At 4101 Rue Sherbrooke Est, Montréal.
Call 514-872-1400.
Visit www.ville.montreal.qc.ca/jardin.
Price: About $16 for adults during peak
season mid-May to mid-October.

Maisonneuve Park (10)

Compared to its neighbor, the Montreal Botanical Garden, Maisonneuve Park offers a more open green space and free access (parking fees extra) if you just want a good vantage point from which to capture the Olympic

St. Lawrence Seaway ecosystem, Montreal Biodome

the largest parrot species in the world, to a very friendly resident gray-winged trumpeter that occasionally likes to mingle with visitors along the pathway of the tropical forest ecosystem—this bird is not camera shy at all.

Silhouettes make the perfect foreground and are best explored in front of the 660,000-gallon water tank, home to a variety of sea life in a pool of aqua blue.

Tripods are not allowed inside, and the space gets busy on weekends. You'll also have to play with lighting exposures, especially when shooting toward the ceiling, which combines lush dark greenery and bright natural lighting overhead.

At 4777 Ave. Pierre De Coubertin, Montréal.
Call 514-868-3000.
Visit www.ville.montreal.qc.ca/biodome.
Price: About $16 for adults.

Tower (not the full stadium) with the occasional cyclist or jogger in the foreground. If you want to capture Quebecois-style pride, the park revs into complete party atmosphere every June 24 on St. Jean Baptiste Day (think St. Patrick's Day meets the Fourth of July). The color exploration of the day: a white *fleur de lys* on the blue background of the Quebec flag, which on that day will number well into the thousands. Expect live music and a crowd.

At 4601 Rue Sherbrooke Est, Montréal.
Call 514-872-6555.

Montreal Biodome (11)

One of Montreal's more famous and busier attractions is the Montreal Biodome, a kid-friendly place for indoor urban wildlife. The space was built as the Velodrome bicycle racing circuit for the 1976 Summer Olympics and converted to the Biodome in 1990. It now houses four recreated ecosystems: a tropical forest, a Laurentian Forest, the St. Lawrence Seaway, and a polar world. The ecosystems offer 75 species of birds that number about 350 creatures—some are easier to spot than others, like the resident pair of blue hyacinth macaws,

Olympic Stadium and Park (12)

The aliens have landed. One of the Montreal's more recognizable landmarks is Olympic Tower and Stadium—The Big O—which was built for the 1976 Summer Olympic Games. The tower, which ranks as the tallest inclined tower in the world, combined with the building's retractable roof, resembles a space ship from a variety of angles. (It seems aliens can make a whole baseball team disappear, as the Montreal Expos played their last game there in 2004.) I love the abstract qualities of photographing Olympic Stadium.

Exterior shots in the morning are best if taken near the funicular/pool entrance adjacent to the Montreal Biodome (near Viau Metro station). Afternoon shots are best from the corner of Sherbrooke Street and Blvd. Pie-IX (Metro station Pie-IX), but be careful as it's a busy intersection traffic-wise (and attractions-wise as well: the Montreal Botanical Garden claims

one corner, while Château Dufresne takes the opposite side of the street). Colorful flags from the nations that participated in the games adorn the site.

A funicular ride to the observatory at the top of the tower lets you shoot from a height of about 525 feet, but you are enclosed in glass. While it's worth the fun ride to the top, the view of downtown may be too far away for a good shot (a closer downtown perspective—with free admission—is better from the Mount Royal Park Belvedere).

At Boulevard Pie IX and Rue Sherbrooke. Call 514-252-4737 or 1-877-997-0919. Visit www.rio.gouv.qc.ca.
Price: Free to access the plaza, about $14 for the observatory visit.

Château Dufresne (13)

Château Dufresne is one of Montreal's finest examples of 1920s Beaux-Arts style architecture. This grand mansion, built for wealthy bourgeoisie brothers Marius and Oscar Dufresne, consists of 22 rooms and, most in-

Olympic Stadium

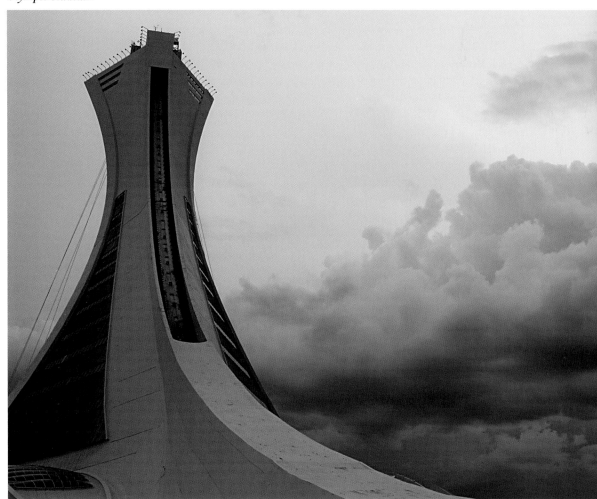

teresting, the house was split in two—one half for each brother.

Exterior shots are best taken afternoons from the front of the building—the sun will be at your back, and the shot won't include the canopy that covers the main entrance near the rear parking lot. It gets even better inside as ornate moldings, doors, windows, woodwork, period furnishings, and ceiling frescoes artistically inspire your architectural photography muse. Much of the building's interior was designed by immigrant artist Guido Nincheri, who also decorated a number of Montreal churches. Flash is not permitted inside.

Professional photographers use the space all the time—the site remains a popular set for period television and movie shoots, as well as the backdrop for brides and grooms on their big day.

At 2929 Ave. Jeanne d'Arc (corner
 Rue Sherbrooke and Blvd. Pie-IX),
 Montréal.
Call 514-259-9201.
Visit www.chateaudufresne.com.
Price: About $7.

Maisonneuve Market (14)

Founded in 1915, Maisonneuve Market has lived an illustrious and varied history—everything from a political assembly gathering place to a boxing arena. The building to photograph that bears the Marché Maisonneuve moniker is now a community center. It was designed by architect Marius Dufresne, who also designed his Beaux-Arts style residence, Château Dufresne mentioned before. The actual market shares the plaza space to the east of the main building and features a number of fruit and vegetable vendors—you can't miss it.

Similar to Olympic Tower, which looms large behind the eastern side of the market, façade and plaza entrance shots are best taken in the morning hours. If you prefer a more bustling market atmosphere for your photo subjects, make your way to Atwater or Jean-Talon Markets.

At 4445 Rue Ontario Est, Montréal.
Call 514-937-7754.
Visit www.marchespublics-mtl.com.

More Beaux-Arts style architecture can be found across the street from the market at the Maisonneuve Public Bath, designed in 1916, again by Marius Dufresne (1875 Blvd. Morgan), and Maisonneuve City Hall (corner Blvd. Pie-IX and Rue Ontario), which was designed by Cajetan L. Dufort in 1911.

Heading back toward the Big O, the newest stadium in town belongs to the local soccer team, the Montreal Impact, First Division members of the United Soccer Leagues. The stadium, inaugurated in 2008, offers nonstop soccer action to satisfy the sports photographer in you, as well as a good view of the Olympic Tower (although you'll be facing the sun during afternoon games). Cameras are allowed—bring the telephoto lens—but photos cannot be used for commercial purposes. The season runs April to October.

At 4750 Rue Sherbrooke Est (Viau Metro
 station).
Call 514-328-3668 or
visit www.montrealimpact.com.
Tickets start at about $10.

III. Old Montreal and the Old Port

General Description: While Old Montreal and the Old Port are the main draws for visitors, the area equally accommodates the locals who like to play as there's always something to do. The area also offers some of the best hotels and finest restaurants in the city.

Directions: You can walk if you're staying at any Old Montreal hotel. The area is serviced by three Metro stations. For Old Montreal points east, get off at the Champ-de-Mars Metro station to visit the likes of Bonsecours Market, City Hall, and the Clock Tower (in fact, the Metro station itself is worth photographing). Centrally located is Metro station Place d'Armes, located at Palais de Congrès (the Montreal Convention Centre). It's close to the Notre Dame Basilica. The Square Victoria Metro station will leave you near Pointe-à-Callière. For more information, visit www.quaysoftheoldport.com and www.vieux.montreal.qc.ca.

Where: Just south of the downtown core
Noted for: The place where Montreal was born
Best Time: Spring through fall
Exertion: Minimal (for walking)
Parking: Metered street parking is available but not always easy to find. Pay parking lots are available next to the Montreal Science Centre and at the Clock Tower Quay.
Metro Stations: Champ-de-Mars, Place d'Armes, Square Victoria
Sleeps and Eats: Too many to mention here, I'll tell you what's near each listing.
Sites Included: Bonsecours Market, City Hall, Notre Dame Basilica, St. Lawrence River boat tours
Area Tips: There are many wonderful photo ops in the Old Montreal and Old Port part of town. Spend the day—you'll be delightfully surprised.

Marguerite Bourgeoys Museum and Notre-Dame-de-Bonsecours Chapel (15)

Located in the eastern end of Old Montreal, this museum and working chapel combine to tell the story of Marguerite Bourgeoys, one of Montreal's first settlers and considered Montreal's first teacher. The current chapel, known as the sailors' church, dates to 1771. The ornate interior boasts intricate architectural details such as carved replicas of sailing ships that hang from the vault. Flash is not allowed inside. The museum features an archaeological dig site, which reveals remnants of the original chapel built in 1675. From the museum, you can access the tower for great views of Old Montreal. With its majestic spires and splendid roof details, the tower itself makes for a great photo close-up as well.

You can take the exterior shots from the rear of the building along Rue de la Commune, or capture the front for a unique perspective along Rue Bonsecours.

At 400 Rue St-Paul Est, Montréal.
Call 514-282-8670.
Visit www.marguerite-bourgeoys.com
Price: Chapel visit is free; museum visit costs about $8.

Pierre du Calvet Inn and Restaurant (16)

Maison Pierre du Calvet dates to 1725 and is considered Montreal's oldest inn. (Benjamin Franklin stayed there way back when.) It's still a working bed & breakfast today.

A wonderful shot of this New France structure, complete with cobblestone street in the foreground, can be had from Bonsecours

Market, located diagonally across the street. Unfortunately, parked cars don't add to the New France feel. The restaurant is highly recommended for weekend brunch.

At 405 Rue Bonsecours, Montréal.
Call 514-282-1725.
Visit www.pierreducalvet.com.

Bonsecours Market (17)

Old Montreal's majestic neoclassical Bonsecours Market dates to 1847 and once played home to Canada's Parliament (for two weeks) in 1849. This is one of my favorite buildings to photograph in the city.

It's not easy to squeeze all the architectural elements into the frame when shooting the building from the front. Instead, focus on part of the building. For example, the occasional horse-drawn carriage parks near the main entrance under the building's trademark silvery dome.

Rear-view shots provide an equally grand exterior and, more important, enough distance between you and the building so that you may

Pierre du Calvet Inn, Old Montreal

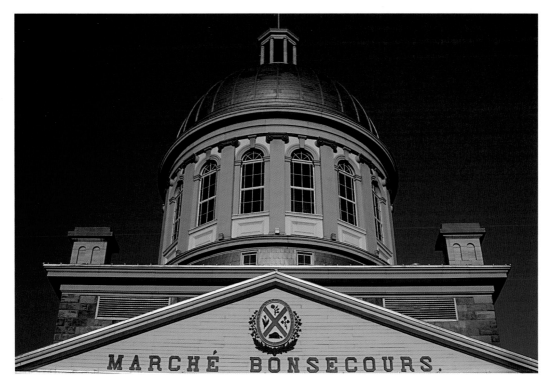

Marché Bonsecours

capture the perspective of the entire edifice. Try shooting from the Clock Tower Quay parking lot entrance to add the modern city skyline to the background; from the Bonsecours Basin pier to include an element of water and reflection; or from the elevated walkway on the Jacques Cartier Quay to add a sense of height to the foreground.

The interior market houses upscale, mostly made-in-Quebec souvenirs and high-end crafts and very clean public restrooms.

At 350 Rue St-Paul Est, Montréal.
Call 514-872-7730.
Visit www.marchebonsecours.qc.ca.

The Clock Tower (18)

The Clock Tower has been a beacon for ships visiting Old Port since 1922. It was built as a memorial to World War I sailors who perished at sea. The soft manila hue of the tower often pops against a bright blue sky. Exterior shots can be had on land—from the pier parking area, or by sea—appropriately with water in the foreground aboard any number of St. Lawrence River cruises.

From mid-May to Labor Day, the interior of the tower is open to visitors. If you've got the energy, climb all 192 steps to the top for great views of the Old Port and the St. Lawrence River.

At the Clock Tower Quay.
Visit www.quaysoftheoldport.com.
Price: Donation.

Montreal by Sea—Old Port Cruises (19)

The Old Port offers a number of St. Lawrence River cruises that let you capture the city as your subject with nautical elements in the

foreground. Here's how to go for a boat ride—Montreal-style.

AML Cruises offers hour-and-a-half daytime excursions to the nearby islands of Boucherville, as well as dinner and fireworks cruises (514-842-3871, www.croisieresaml.com).

Le Bateau Mouche is an Old Port staple and offers St. Lawrence River sightseeing and evening dinner cruises in a glass-enclosed boat (514-849-9952, www.bateau-mouche.com).

Le Petit Navire offers 45-minute nautical jaunts of the Old Port waterways (514-602-1000, www.lepetitnavire.ca).

The St. Lawrence River shuttles or *navettes* embark on mini-cruises from the Jacques Cartier Quay to Longueuil on the South Shore and then to Jean Drapeau Park. It's a bargain at about $7 for a one-way trip (514-842-1201, www.navettesmaritimes.com).

Château Ramezay (20)
Built in 1705, the house once belonged to Claude de Ramezay, a former New France gov-

Montreal by sea

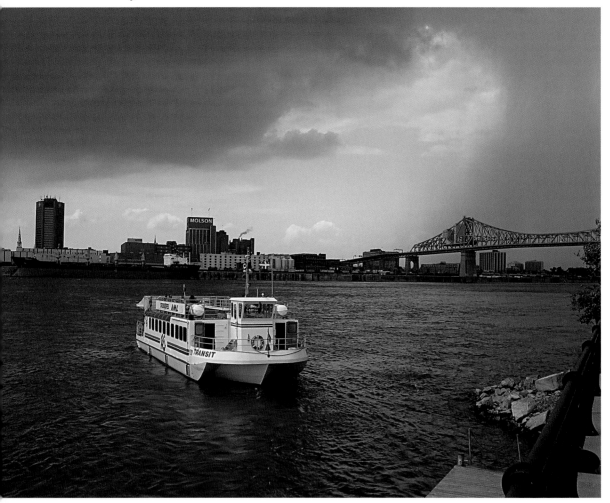

Montreal City Hall rooftop

ernor of Montreal. The space now claims the distinction of being Montreal's oldest private museum, which dates to 1895. The collection reflects the history of Montreal's strategic place in Canadian and American history as the Château once served as American headquarters during the Revolutionary War, when Montreal was briefly part of the United States, from fall 1775 to summer 1776.

The artifacts include books, coins, photographs, and documents, including a signed letter from Benjamin Franklin, who visited the Château Ramezay for a reception in 1776 to drum up support for the American Revolution. You can practice the art of capturing museum artifacts, as photographs are allowed inside, but no flash.

Exterior shots offer architectural details of this New France home as well as the Governor's Garden, a recreated New France–style residence farm.

> At 280 Rue Notre Dame Est, Montréal.
> Call 514-861-3708.
> Visit www.chateauramezay.qc.ca.
> Price: Free grounds access, about $10 for
> museum visit.

City Hall/Champs-de-Mars (21)

Hôtel de Ville, or City Hall, dates to the 1870s and was designed in the time-appropriate Second French Empire style of architecture. The building is often dramatically lit through all four seasons and is a favorite Montreal photo opportunity for tourists and locals alike.

A word of note: a new copper roof and bell tower repairs are scheduled on City Hall until

2010. This means that scaffolding will block the view of portions of the building. In addition, if you don't want entire wedding parties in your shot, avoid the area on summer weekends, as the space is quite popular with newlyweds (justice of the peace ceremonies are held around the block).

Just behind the building is the Champs-de-Mars public square, where visitors can see remnants of the New France–era fortified wall of Ville-Marie. The green space adds foreground to shots of the downtown core (best taken in the morning hours) as well as a roomy vantage point from which to capture architectural details of City Hall from behind (best taken in the afternoon).

The nearby Champ-de-Mars Metro station is one of the more colorful stations in town. The abstract stained-glass window façade was designed by Quebec artist Marcelle Ferron.

At 275 Rue Notre Dame Est, Montréal.
Call 514-872-3101.
Price: Free guided tours during weekdays.

Place Jacques-Cartier (22)

Place Jacques-Cartier, the center of Old Montreal, is one of the oldest public squares in Canada. The photographic subjects of note include lots of people: tourists and locals, street performers and buskers, flower vendors, and artists with easels painting portraits and caricatures of visiting clients.

The shot from Rue de la Commune offers a sweeping perspective upward past outdoor patios with City Hall in the background. You may also be able to squeeze in the Place Jacques-Cartier monument near Notre Dame Street, which pays homage not to Cartier but to Lord Nelson.

Where: Centered between Notre Dame and de la Commune Streets, diagonally across from City Hall.

Notre-Dame Basilica (23)

This is Old Montreal's iconic and ornate neo-Gothic style church that charges admission to get in but is well worth the visit. The building dates to 1829, but the first tower wasn't completed until a decade later, while the interiors weren't completed until the 1870s.

Exterior shots are nice; interior shots are better. Capture close-up design elements such as intricate wood carvings, stained glass windows, a Casavant Frères organ, and a colorful, busy, but breathtaking altar. Sorry, no flash inside.

At 110 Rue Notre-Dame Ouest, Montréal.
Call 514-842-2925.
Visit www.basiliquenddm.org.
Price: About $5.

Place d'Armes (24)

This compact public square is surrounded by sumptuous Old Montreal architecture. You may need a wide-angle lens to squeeze everything into the frame or you can capture a variety of architectural details with every turn. What to shoot? Here's a quick inventory.

The square's centerpiece monument pays homage to Paul Chomedy de Maisonneuve, one of the founders of the city. The statue also pays tribute to other settlers, including Jeanne Mance, Lambert Closse, Charles LeMoyne and an Iroquois that represents the Iroquois nation. With the monument in the foreground, look toward the Notre Dame Basilica—there's almost always a *calèche*—a horse-drawn carriage—parked in front of the church. To the right of the basilica is the St. Sulpice Seminary, the oldest building in town.

Make an about-face and look for the domed building with six stately columns—that's the Bank of Montreal on Rue St. Jacques, which was once home to the country's financial district and is worthy of a photographic stroll. The

building dates from 1847 and houses a small free museum that highlights banking. Just to the right you'll find the Royal Trust Building and then the Place d'Armes Hotel—quite nice digs in town. Continue to the New York Life Insurance Building—the edifice with the beautiful clock. Then just to the right, the art deco era is evident in the Aldred Building, which was built in 1931 and indeed inspired by the likes of the Empire State and Chrysler Buildings.

Where: Bordered by Rue Notre Dame and Rue St. Jacques

Pointe-à-Callière, the Montreal Museum of Archaeology and History (25)

Dig this! Local archaeologists consider Pointe-à-Callière the birthplace of Montreal—they believe this is where Paul Chomedy de Maisonneuve and Jeanne Mance founded Ville-Marie in 1642. The museum even houses the remains of the first Catholic cemetery of Montreal's earliest settlers. The site was the former residence of Montreal's third governor, Chevalier Louis-Hector de Callière, the museum's namesake.

During the late 1980s, just before construction of the museum, archaeologists discovered about 700,000 artifacts on the site. The museum officially opened its doors in 1992. This new modern structure, with its landmark tower, makes for a lovely focal point when shooting the converted warehouses that line Rue de la Commune.

In addition, you can visit the museum's belvedere without paying for exhibition

Place d'Armes monument

admission. The space is tight—no room for a tripod up there, but you will get a bird's-eye view of Old Montreal and the Old Port with Rue de la Commune again offering a nice street perspective to the Jacques Cartier Bridge in the distance. The adjacent Old Customs House at Place Royale, which dates to 1836, houses some of the museum's temporary exhibitions and gift store. For lunch, try the on-site café or the nearby Olive et Gourmando (351 Rue St-Paul Ouest).

At 350 Place Royale, Montréal.
Call 514-872-9150.
Visit www.pacmuseum.qc.ca.
Price: About $12 for adults.

Centre d'Histoire de Montréal/Montreal History Center (26)

If you time it just right, an iconic *calèche* horse and carriage will ramble along the cobblestone street past the CHM for that perfect Old Montreal shot. As the refurbished Place d'You-ville fire station that dates from 1903, the CHM building makes the perfect backdrop. In between frames, sneak inside, as the CHM collection boasts wonderful historical treasures and a very impressive photo collection that chronicles the city's history.

In addition, every year the CHM presents an annual photo contest in conjunction with the local heritage campaign. In the past, the *Montréal a l'oeil* photography contest has thematically captured everything from Montreal residences to industrial architecture. The contest is open to amateur and professional photographers alike. The deadline is usually mid-October, and winning photographs are displayed in an exhibition the following year.

At 335 Place d'Youville, Montréal.
Call 514-872-3207.
Visit www.ville.montreal.qc.ca/chm.
Price: About $6 for adults.

While You're in the Neighborhood: Other Historic Buildings of Note—Customs House, Centaur Theatre, Rue St-Jacques, St. James Hotel (27)

The Customs House (110 Rue McGill) is such a grand and magnificent building that you can almost hear the whispers of "Anything to declare?" when passing by! The structure was built between 1912 and 1916 and is still used today for government offices. A shot from McGill Street when facing the river is best in the afternoon. A wide-angle will let you capture the side and front of the building with the Old Port silos in the distance. Lunch at Cluny ArtBar around the block (257 Rue Prince) is highly recommended.

The Centaur Theatre (453 Rue St-François Xavier), Montreal's premier English-language theater, is housed in the former Old Stock Exchange building.

Rue St. Jacques offers iconic Old Montreal architecture at its best. Of note is the St. James Hotel (355 Rue St-Jacques), the pricey hotel of choice for the likes of Madonna and the Rolling Stones, when they're in town.

Old Montreal Lobbies of Note: World Trade Centre, Nordheimer Building, Bank of Montreal, Royal Bank Building (28)

The Montreal World Trade Centre (747 Victoria Square) office complex lobby offers an atrium, fountain, and granite reflecting pool worthy of a shot, as well as a complete wall of the Nordheimer Building.

Speaking of the Nordheimer Building (360 Rue St-Antoine), it's now part of the Inter-Continental Hotel. The Nordheimer Building lobby offers cast-iron columns, elegant woodwork, and ornate ceiling mosaics.

The Bank of Montreal lobby (119 Rue St-Jacques) is an impressive, opulent space with grand columns.

Next wicket, please! The Royal Bank Build-

Montreal Customs Building

ing lobby (360 Rue St-Jacques) offers splendid vaulted ceilings and authentic wickets, complete with ornate iron bars.

Area Festivals: Old Port Tango

It takes two to tango, but it takes three to photograph the fun. Montreal's Old Port hosts free tango lessons, usually every Friday night in August. Since the sessions are held at night, you'll have to play with or without your flash. While there may be a lack of light, there's no lack of romance. Focus on the twirl of a skirt, or two dancers embraced against the backdrop of the Bonsecours Market with its dome bathed in colored light. Bring the tripod for sure, but also bring a friend, for two reasons: the place gets a bit busy and you'll need someone to watch your gear, and after listening to that live Argentinean tango orchestra, you may be in the mood to dance.

> At Place des Vestiges along the Quays of the Old Port promenade.
> Visit www.tangolibre.qc.ca.

Montreal Plateau mural

IV. Gay Village/Latin Quarter/Plateau/ Mount Royal Park

SPRING SUMMER FALL WINTER

General Description: Montreal's Gay Village and Plateau are working-class residential neighborhoods that offer some architectural gems. The Latin Quarter adds thousands of students to the mix. Mount Royal Park and Lafontaine Park provide tranquil relief for all of these hurried urban souls.

Directions: There is a bit of ground to cover, but public transportation by Metro and bus is available throughout these neighborhoods. The Gay Village is serviced by Metro stations Berri/UQAM, Beaudry, and Papineau. The Latin Quarter is serviced by Metro station Berri/UQAM. And the Plateau is accessed by Metro stations Sherbrooke, Mount Royal, and Laurier. And although Mount Royal Park could easily have been listed under the downtown section, car and public transportation is accessible from the Plateau district near Mount Royal and Park Avenues. The photo tour starts in the southwest corner of the village, makes its way west toward the Latin Quarter, north to the Plateau, and west again toward the mountain (Mount Royal Park).

Where: Three adjacent city neighborhoods and a famed green space not far from the downtown core

Noted for: Montreal's iconic winding staircases, colorful festivals that celebrate fireworks, street performers, and drag queens (how's that for a combination!), and a mountain in the middle of a city.

Best Time: Spring through fall

Exertion: Minimal (for walking); moderate (for hiking up the mountain)

Parking: Free and metered street parking and public lots are available in all these neighborhoods.

Sleeps and Eats: There are tons of restaurants and cafés—in fact, some of the best the city has to offer. The area also boasts a few of Montreal's larger hotels and some of the best B&Bs in town—specifically in the Gay Village.

Sites Included: Jacques Cartier Bridge, Mount Royal Park

Area Tips: Summer festival season means lots of street closings. Be prepared to follow a detour if driving.

La Prison des Patriotes Exhibition Centre (29)

The Centre pays tribute to the rebellious Quebec Patriotes who fought for French rights against British rule during the Lower Canada Rebellion of 1837–1838. This neoclassical-style building was formerly the Pied-du-Courant Prison, where more than 1,200 rebels were imprisoned and another dozen were hanged. It's now home to a museum as well as the SAQ—*Société des Alcools du Quebec*—the provincial-run liquor board. The Jacques Cartier Bridge—you can't miss it as it's practically overhead—makes the perfect dramatic backdrop.

At 903 Ave. de Lorimier, Montreal
Call 450-787-9980
Visit www.mndp.qc.ca

Jacques Cartier Bridge (30)

New York boasts the Brooklyn, San Francisco's got the Golden Gate, and Montreal lays claim to the Jacques Cartier Bridge, which was

opened in 1930. It's not the only bridge in town, but it is the most easily accessible and worth photographing—especially if you're a fan of spans. There are a number of vantage points from which to capture the bridge (it's mentioned throughout the book where appropriate, as it makes such a great background element):

- From the Gay Village: along Avenue de Lorimier near Boulevard de Maisonneuve.
- From the Old Port of Montreal (the Quays of Montreal) along the main promenade. This shot will offer the full horizontal span.
- From Jean Drapeau Park, specifically from the Stewart Museum parking lot.
- From the St. Lawrence River. Hop on the river shuttle to get directly under the bridge from the water.

In addition, you can also access the bridge by foot or bike, as a pedestrian path runs along the length of the span (it's open spring through fall). You're separated from the vehicular traffic, but it's not for the faint of heart. Incidentally,

Montreal Gay Village Ecomusée du Fier Monde

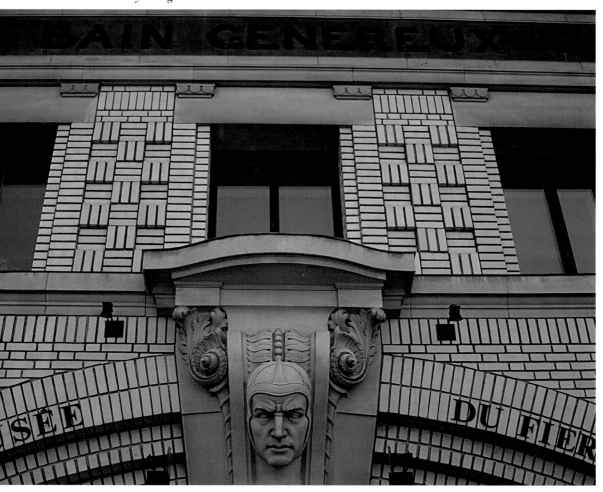

suicide barrier bars were installed in 2005, so you can view the area in complete safety. Access the pedestrian path to the bridge from the Gay Village near Rue Dorion north of Boulevard de Maisonneuve or from Jean Drapeau Park near the Stewart Museum parking lot.

While you're in the neighborhood, Au Petit Extra is recommended for French bistro fare (1690 Rue Ontario Est, 514-527-5552).

Usine C (31)

Usine C adds industrial architecture to the photographic mix. The area once combined residential neighborhood with light industry. In fact, the word *usine* translates to *factory*. (Usine C is where they once made jam.) The building is now a modern theater, but many original architectural elements remain, including the warehouse feel and trademark smokestack. If you're in the area, I dare you to walk past the colorful Victorian-style house on Rue de la Visitation near Usine C's side entrance without taking a few shots.

At 1345 Ave. Lalonde, Montréal (one block south of Ontario Street between Visitation and Panet Streets).
Call 514-521-4198.
Visit www.usine-c.com.

Ecomusée du Fier Monde (32)

Ecomusée du Fier Monde (which translates to "Museum of a Proud World") highlights the neighborhood's legacy as the onetime heart of Montreal's industrial revolution. The museum, appropriately housed in the former Genereux Public Bath, was built in the 1920s to improve the health of working-class Montrealers when apartments lacked their own shower or bath facilities. A wide-angle lens works best to capture the original exterior, although parked cars may be in the way. You can also opt for an architectural detail close-up of the façade's affable

stone face. The pool area now serves as an art gallery and museum space, which often highlights photographic exhibitions. Photos are not allowed inside, but it's worth a peek. Cross the street to capture a small but colorful market atmosphere as well as a snack at the St. Jacques Market.

At 2050 Rue Amherst, Montréal.
Call 514-528-8444.
Visit www.ecomusee.qc.ca.
Price: About $6.

La Grande Bibliothèque Nationale (33)

Montreal's popular public library has been a hit since it opened in 2005. The open and airy building design features four floors, yellow birchwood interiors, and an exterior façade of 6,000 frosted green glass plates. The exterior shot is best achieved at Émilie Gamelin Park across the street, but keep an eye on your gear in this area. The library's exhibition space often displays archival photography of Quebec people and places through a number of free exhibits.

At 475 Blvd. de Maisonneuve Est, Montréal.
Call 514-873-1100.
Visit www.banq.qc.ca.

Lafontaine Park (34)

Lafontaine Park is where the local residents of the Plateau and Village neighborhoods come to play—and unwind—in a big way. The park features landscaped gardens, public statues and sculptures, and two manmade ponds. In summer, capture the likes of bocci ball players and inline skaters. During fall, the park's trees offer a mini-symphony of urban autumn colors. In winter, figure skaters take center frame.

In the Plateau, bordered by Rue Sherbrooke, Avenue du Parc Lafontaine, Rue Rachel, and Papineau Avenue.

Montreal calèche *horse-drawn carriage at Mount Royal belvedere*

Plateau Architecture/Winding Staircases/ Grand Entryways/Murals (35)

The Plateau neighborhood adds residential architecture to the photographic mix. These residential streets offer rows of three-story-tall urban apartment houses, most built during the 1920s. Many of the houses feature architectural attributes such as stained glass windows and those iconic winding staircases for which Montreal is so famous. In addition, local heritage campaigns offer prizes to houses that maintain a vintage feel as well as offer photo contests to capture the unique characteristics that define the area's buildings. (More contest info can be found in the Centre d'Histoire de Montreal entry in Chapter III, Old Montreal.) A word of note: you're photographing someone's house, so please be respectful of your surroundings.

You're bound to find a shot or two along any number of Plateau streets bordered by Rue Rachel/Lafontaine Park to the south, Avenue de Lorimier to the east, Boulevard St. Joseph to the north, and Mount Royal Park to the west. Bear in mind that there is a bit of ground to cover.

Enjoy brunch, lunch, happy hour, dinner, and shopping at any number of restaurants and boutiques along Avenue Mount Royal, Rue St-Denis, and Blvd. St-Laurent.

Mount Royal Park/The Cross/Downtown Skyline (36)

Montreal's green gem in the heart of the city is indeed Mount Royal Park. It was designed by Frederick Law Olmstead, who also designed New York's Central Park. The summit's belvedere offers a beautiful panorama of downtown and beyond, including the St. Lawrence River and Mount St. Bruno 15 miles away. The sun will be at your back during afternoon hours. The parking area along Camillien Houde Drive offers eastern views of the city, including Olympic Stadium.

You can add people to the frame, in the form of cross-country skiers and sledders during winter and cyclists and those who just want to lounge the day away during summer. A sculpture circuit adds abstract art to the photos, while a winter birdwatching trail offers mountain-style fauna. A colorful dose of fall foliage so close to any downtown core doesn't get any better than this.

The mountain's famous cross can be taken from up close near the belvedere, but a shot from below along Avenue du Parc with the Sir George Étienne Cartier monument in the foreground works equally well. The Smith House —located near the main parking lot closest to the Chalet and lookout—offers a small museum, café, and boutique with maps of the park. Except for parking, this visit is free.

Access from downtown at the corner of Rue Peel and Avenue Pins Ouest (you'll have to carry your gear uphill and up a long staircase) or from the Plateau at the corner of Avenue

Mount Royal and Avenue du Parc. Public transportation is available from Mount Royal Metro station with a transfer to bus number 11 west.

Call 514-843-8240
Visit www.lemontroyal.qc.ca

While You're in the Neighborhood— Streets and Other Historic Buildings of Note: Rue St-Denis, Edifice Gilles Hocquart, St-Jean-Baptiste Church (37)

Rue St-Denis in the Latin Quarter offers bustling street life, outdoor cafés, and a number of building façades of note, such as the St-Denis Theatre (1594 Rue St-Denis).

Walk south past Boulevard René-Lévesque to the Old Montreal border to capture wonderful architectural details on Edifice Gilles Hoc-quart, which houses the National Archives of Quebec (535 Ave. Viger Est).

The heart of the Plateau district offers a magnificent architectural gem, the St-Jean-Baptiste Church, which unfortunately is open only for specific events. The outside is still worth a shot (309 Rue Rachel Est).

Area Festivals: Montreal International Fireworks Competition, Just for Laughs Festival, Gay Pride Parade (38)

The Montreal International Fireworks Competition is a summer staple around these parts—some 200,000 people attend each fireworks show. The show is hosted at La Ronde Amusement Park, but there are a number of places to watch and capture the fireworks for

Edifice Gilles Hocquart (National Archives Building)

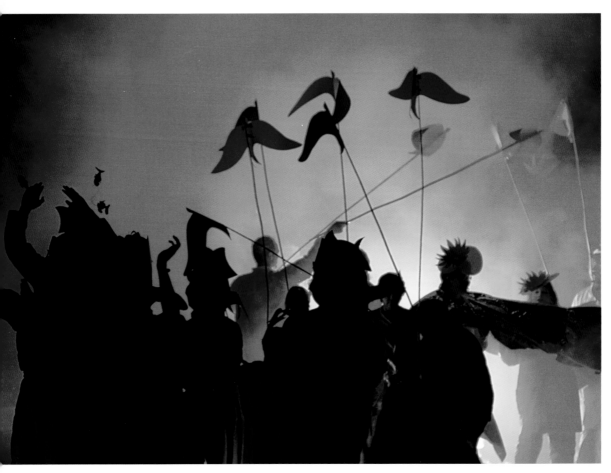

Just for Laughs night parade

free: the Old Port of Montreal, Jean Drapeau Park, and in the Gay Village with its close proximity to the Jacques Cartier Bridge, which is closed to vehicular traffic on fireworks nights. To get to the bridge, go to the Papineau Metro station and just follow the crowd. There are 10 shows each summer in late June and throughout July—usually Wednesday and Saturday nights. It's held at 10 PM, rain or shine. Bring the tripod. Visit www.montreal fireworks.com.

The Just for Laughs Festival tickles your funny bone every July. The fun photo ops, usually held all along Rue St-Denis in the Latin Quarter, include roving street performers, boisterous buskers, and at least three or four parades every year—one devoted to hundreds of pairs of twins, as well as a colorful nighttime parade held downtown that closes the festival. Again, bring the tripod. Visit www.hahaha .com.

Montreal hosts two gay pride celebrations, a week of music and parties in early August, and a parade, which is held in late July or mid-August. If you've a need to photograph animated floats full of leather and sequins, opt for the parade. Visit www.celebrations-lgbta.org and www.diverscite.org.

V. Downtown/Surrounding Neighborhoods

SPRING ★★★ SUMMER ★★★★ FALL ★★★★ WINTER ★★★

General Description: The buildings are all around you. While I can't include all of Montreal's magnificent skyscrapers, the grouped listings will situate you near some well-known city structures. It's up to you to explore the surrounding streets to capture the unique skyline slice of your choice.

Directions: The downtown core is "west" of the Gay Village and Latin Quarter, "north" of Old Montreal, and "south" of the mountain. Keep in mind that these "directions" don't exactly follow points on a compass, but rather Montrealers' perspective in terms of the street grid and directional feel of the St. Lawrence River. That said, St. Laurent Boulevard is the official east-west divider of city.

Where: Mostly the downtown core of Montreal
Noted for: Urban architecture old and new
Best Time: All year long
Exertion: Minimal (walking)
Parking: Metered street parking, hotel parking
Metro Stations: The Green Line between the Berri/UQAM and Atwater stations and the Orange Line between the Place D'Armes and Lionel-Groulx stations
Sleeps and Eats: All the major hotels—Delta, Hilton, Sofitel—have downtown locations. Endless eateries as well.
Sites Included: Palais des Congrès, downtown skyscrapers, St. Joseph's Oratory
Area Tips: Public transportation is the way to go.

Musée d'Art Contemporain/Place des Arts Esplanade (39)

Musée d'Art Contemporain is the place for contemporary art in Montreal. There's often an eclectic exhibition inside for artistic inspiration, no matter what your discipline.

The esplanade that shares the space with the Place des Arts entrance offers a reflecting pool painted a new color every summer, a summertime outdoor art installation, and Mount Royal and its cross in the background. There are usually people around to add to the frame—from a few folks lounging near the water to thousands who show up for Montreal's International Jazz Festival every summer.

In addition, the esplanade lays claim to a major photo phenomenon: controversial photographer Spencer Tunick convinced 3,000 Montrealers to appear nude when he photographed them there in 2002. (Okay, it really didn't take too much convincing on Tunick's part!)

At 185 Rue Ste-Catherine Ouest, Montréal (Metro station Place des Arts).
Call 514-847-6226.
Visit www.macm.org.
Price: About $10. Free museum admission Wednesday evenings.

Christ Church Cathedral/KPMG Tower (40)

What do you do when you need to construct a city skyscraper and an underground mall when there's a church in the way? Pick up the church, support it on stilts, excavate the ground, and replace the church.

That's what happened to the Christ Church Cathedral in 1987. Today the neo-Gothic architecture makes the perfect foreground to the pink glass-paneled façade of the KPMG Tower in the background. The church offers wonderful close-up architectural details of gargoyles as well.

At 1444 Avenue Union, Montréal (Metro station McGill).

Christ Church Cathedral gargoyle

McCord Museum of Canadian History (41)

Founded in 1921, the McCord Museum is a treasure trove for all things Canadian. The collection numbers 1.3 million objects—everything from period furnishings to authentic folk art to First Nations artifacts. Photos of collection (without flash) are allowed inside.

Most impressive is the collection of about one million photographs—almost half taken by acclaimed photographer William Notman, whose studio captured Montreal history from the 1840s to the 1930s. A variety of photos are usually displayed in the third floor archives exhibition hall.

An exterior shot of note is of the authentic Inukshuk sculpture made of 200 slabs of stone near the entrance. Stay for lunch at the on-site, popular McCord Café.

At 690 Rue Sherbrooke, Ouest, Montréal (Metro station McGill).
Call 514-398-7100.

Visit www.mccord-museum.qc.ca.
Price: About $12.

McGill University Campus/Redpath Museum/McGill College Avenue Skyscrapers (42)

Located on the campus of McGill University, the Redpath Museum was named after donor John Redpath, whose local sugar refinery made him a very rich man. The neoclassical-style building dates to 1882 and is stunning inside and out. The collection emphasizes natural history and includes fossils, minerals, gems, and an Albertosaurus dinosaur skeleton.

You can capture the Redpath Museum building in the foreground with Mount Royal Park ever prominent in the near distance. A word of note: this is a working campus, so be considerate of the students.

At the front entrance, you'll find McGill College Avenue, which offers a downtown slice of modern buildings and public art on both sides of the street. Included along this canyon of skyscrapers are the BNP Tower, the McGill College Tower, and Place Ville Marie.

About eight blocks from the back entrance of the main campus along Avenue des Pins, you'll find l'Hôtel-Dieu de Montreal, the oldest hospital in the city.

At 859 Rue Sherbrooke Ouest, Montréal–Redpath Museum (Metro station McGill).
Call 514-398-4086, ext. 4092.
Visit www.mcgill.ca/redpath.
Price: Free.

Montreal Museum of Fine Arts (43)

The Montreal Museum of Fine Arts boasts a wonderfully inspiring collection that includes classic and modern decorative arts, Canadian and European fine arts, and Mediterranean, Asian, African, and South American antiquities—a little something for everyone.

You *can* take photos inside—but only of their permanent collection, and no flash or tripods. MFA's three buildings are architecturally impressive in their own right and are worth a shot—the neoclassic original built in 1912, the more contemporary edifice that opened in 1991 across the street, and the newest addition, the Erskine and American United Church, which was built in 1894 and was recently acquired by the MFA to house its Canadian collection starting in 2010.

At 1379-1380 Rue Sherbrooke Ouest, Montréal (Metro station Guy-Concordia).
Call 514-285-2000.
Visit www.mmfa.qc.ca.
Price: Free for permanent collection; about $15 for temporary exhibits.

Sun Life Building/Mary, Queen of the World Cathedral (44)

The Sun Life Building is a grand, city block-size, photogenic piece of architecture that will surely inspire your muse and keep you busy for a while.

Just across the street on Boulevard René-Lévesque, Mary, Queen of the World Cathedral offers ornate interior dome details and an exterior row of patron saint statues that adorn the façade. It's an irresistible shot of perspective with the Queen Elizabeth Hotel in the background—the color of the curtains, interestingly, matches the color of the sculptures. But with some curtains drawn and others closed at the same time, the shot can appear too messy.

At 1155 Rue Metcalfe, Montréal–Sun Life Building (Metro station Bonaventure).

Place Ville Marie building detail

Windsor Station/Bell Centre/Le 1250 Boulevard René-Lévesque Building (45)

They just don't build them like that anymore. Windsor Station (Gare Windsor) and its immediate vicinity offers a number of photographic architectural gems.

Designed in the neo-Romanesque style of architecture, Windsor Station was built in the late 1880s as the Canadian Pacific Railways headquarters. It's no longer a working train station and now houses office space.

The neighboring Bell Centre adds a modern architectural touch to the frame, while Le 1250 Boulevard René-Lévesque Building adds a glass and steel silhouette just across the street. The Guaranteed Pure Milk Company milk bottle, actually the former dairy's water tower on nearby Avenue Lucien L'Allier offers vintage advertising and Montreal landmark charm to any photo.

Another building to mention is Le 1000 de la Gauchetière, which is located just down the block. Its peaked roof will probably sneak into your Windsor Station background, as it's Montreal's tallest building at 51 floors.

At 1100 Rue de la Gauchetière Ouest, Montréal–Windsor Station (Metro station Bonaventure).

Palais des Congrès (46)

Palais des Congrès, Montreal's Convention Centre, hosts dozens of public and industry trade shows every year, including the Montreal International Auto Show every January. (With its concept car innovations and vintage car displays, the show offers a unique photo op on its own.) The building underwent a colorful renovation in 2002 and features plenty of playful public art to photograph, including Lipstick Forest, a collection of 52 bubblegum-pink tree trunks, a kaleidoscopic multicolored glass façade on its west end along Rue de Bleury, and an inclined window wall along Avenue Viger that lets you capture passing cars reflected from the street below.

At 201 Ave. Viger Ouest, Montréal (Metro station Place d'Armes).
Call 514-871-8122.
Visit www.congres.mtl.

Place Jean-Paul-Riopelle (47)

Place Jean-Paul-Riopelle is an outdoor urban space that's located at the colorful west end of Palais des Congrès. Its centerpiece fountain sculpture, La Joute, was created for the 1976 Summer Olympics by sculptor Jean-Paul Riopelle.

During summer evenings, the park turns into a living, breathing photo op as the entire block fills with mist and the fountain bubbles with water, sprays with steam, and ignites with a ring of fire. It's a mesmerizing mix that's challenging to capture just right.

At the corner of Avenue Viger Ouest and Rue de Bleury (Metro station Place d'Armes).
Visit www.qimtl.qc.ca.

Canadian Centre for Architecture (48)

The CCA is all about the art of architecture. Montreal native and architect Phyllis Lambert founded the CCA as a research center in 1979 and an architecture museum a decade later. It's not your typical museum visit. Instead, urban planning, landscape design, and environmental concerns highlight the always unique repertoire of exhibitions at the CCA.

CCA's modern building is a photo essay in minimalism. It's paired alongside the historic Shaughnessy House, which was built in 1874. Shots of the newer edifice are best in the afternoon with the sun at your back. CCA's Sculpture Garden provides a spot of urban artistic relief as well as a playful photo op on busy Boulevard René-Lévesque just across the street. The specialized bookstore is

Palais des Congrès

stacked with hundreds of architecturally themed titles.

At 1920 Rue Baile, Montréal (Metro station Guy-Concordia).
Call 514-939-7026.
Visit www.cca.qc.ca.
Price: About $10. Free admission Thursday evenings.

Atwater Market (49)

A bountiful harvest, colorful flowers, and ambitious vendors can be captured against an art deco–style structure when visiting Atwater Market. Located in the St. Henri neighborhood southwest of downtown, the structure was built in 1933 and remains a famous Montreal landmark, specifically its trademark tower, and a busy working market—some six dozen vendors call Atwater Market home.

Besides bringing home some great photos, take home a culinary souvenir or two. Specialty shops of note include Les Douceurs du Marché on the main floor, for a wonderful selection of teas, spices, and olive oils (514-939-3902). And just next door, some of the best pizza in town can be sampled at Pizz'ancora.

At 138 Ave. Atwater, Montréal (Metro station Lionel-Groulx).
Call 514-937-7754.
Visit www.marchespublics-mtl.com.

Lachine Canal (50)

The Lachine Canal stretches from Old Montreal to the town of Lachine for about 9 miles. It provided safe passage for ships that needed to avoid the unnavigable Lachine Rapids along the St. Lawrence River. The canal dates to 1825 and is a main reason why Montreal became a major seaport. Its heyday lasted until 1959, when the canal was replaced by the St. Lawrence Seaway.

You can capture great views of downtown, with cyclists and pleasure boats in the foreground. Or capture industrial-style architecture at any one of the five working locks or any one of the dozens of warehouses that line the banks, many of which have been renovated into pricey condominiums.

Near the Atwater Street lock, H20 Adventures (514-842-1306, www.h20adventures.com) offers kayak and electric boat rentals from May to mid-October if you wish to take a shot from the perspective of the water.

The Atwater pedestrian bridge on the Lachine Canal is accessed near the Lionel-Groulx Metro station.

> Visit: www.pc.gc.ca/lhn-nhs/qc/
> canallachine.

Maison St-Gabriel (51)

Dating to 1668, Maison St-Gabriel enjoys the claim of being Montreal's oldest farmhouse and is still home to the Sisters of the Congregation of Notre Dame. The congregation was led by settler Marguerite Bourgeoys, Montreal's first educator, who taught the *filles du roy,* or king's wards, young orphaned girls from Europe who ventured to New France to help offset the disproportionately high male population of the 17th century.

Besides the main house, which remains in immaculate condition inside and out (what did you expect from those nuns?), a nearby barn, a recreated working garden, and costumed guides add to the authentic New France feel. It's a bit out of the way in the Pointe St-Charles residential neighborhood, but accessible by public transportation.

> At 2146 Place Dublin, Montréal.
> Call 514-935-8136.
> Visit www.maisonsaint-gabriel.qc.ca.
> Price: About $8.

St. Joseph's Oratory (52)

While he would probably never take credit, the story of St. Joseph's Oratory is the legacy of Brother André, whose vision it was to build a shrine to St. Joseph. And what a shrine it is.

The first impression is that of a grand, almost imposing structure with a magnificent exterior dome. That the structure is perched atop an elevated hill makes it even more striking from the parking lot below.

It's challenging sometimes to capture the subtleties of a church visit, as no flash or tripods are allowed inside. In addition, you must be considerate of visiting parishioners. Instead, focus on exterior architectural details such as stone columns, sweeping staircases, and a serene Way of the Cross garden. Inside, capture the minimalist interior of the basilica and its colorful stained glass.

The site also features a museum that offers photo documentation of Pope John Paul II's 1984 trip to Montreal.

> At 3800 Queen Mary Rd., Montréal (Metro
> station Côtes des Neiges).
> Call 514-733-8211 or 1-877-672-8647.
> Visit www.saint-joseph.org.
> Price: Free or donation.

One Metro station away, the University of Montreal's main campus offers classic art deco–style architecture and a trademark tower. The campus is obviously much quieter in summer. At Metro station Université de Montréal.

René Lévesque sculpture park

René-Lévesque Park (53)

Art and nature combine to make for a most unique photo op in Montreal's town of Lachine. Here you can find a great collection of more than 50 outdoor sculptures spread out in three locations: Musée de Lachine, Parc René-Lévesque, and Parc Riverains. It's one of the biggest and best places for public art in Canada.

Musée de Lachine offers a dozen and a half sculptures on site. A short distance away and a better photo op is at Parc René-Lévesque, which offers two dozen sculptures and a nearby marina backdrop. There are pedestrian paths for those on bike or foot and plenty of nearby parking. The area is, in fact, where the Lachine Canal bike path ends—or begins, depending on your direction. Travel along St. Joseph Boulevard through the town of Lachine until you reach Parc Riverains, a 3-mile stretch along picturesque Lac St-Louis to discover an additional dozen sculptures.

> Musée de Lachine is at 110 Lasalle Road, Lachine. Continue past the museum to Parc René-Lévesque.
> Call 514-634-3471.
> Visit www.ville.montreal.qc.ca/lachine (the city of Montreal's Web site; it's mostly in French. Click "Musée de Lachine," then "Musée plein air," then "carte de l'arrondissement" for area maps).

International Balloon Festival of Saint-Jean-sur-Richelieu

VI. Side Trips

Where: Mostly Montreal's "South Shore" or the Montérégie region; the Eastern Townships

Noted for: Unique attractions, colorful festivals, rich heritage, and scenic countryside less than an hour from Montreal

Best Time: Summer and fall

Exertion: Minimal to moderate (for walking and hiking)

Parking: All offer on-site parking.

Sleeps and Eats: From camping to B&Bs and ski resorts; sandwich shops to fine dining at a number of countryside villages

Sites Included: Exporail, the Canadian Railway Museum, Mount Orford National Park, Fort Lennox National Historic Site of Canada

Area Tips: Operating hours vary with each season, so check first. And be careful of one word that comes to mind during spring: mud.

General Description: The recommendations here offer a well-balanced variety of the region's photographic possibilities. Most are located in the Montérégie region, an hour's drive or less from Montreal.

Directions: Between the U.S. and Montreal, take Highway 15. To get to the Eastern Townships from Montreal to reach the likes of Orford Park, take Highway 10. Directions are included with each listing.

St. Lawrence Seaway Locks (54)

You don't often get a chance to photograph magnificent oceangoing vessels up close. You can at one of the St. Lawrence Seaway locks on Montreal's South Shore, minutes from the Jacques Cartier Bridge.

These behemoth-size ships, which carry

Deer in Îles-de-Boucherville National Park

freight to and from the Atlantic Ocean and the Great Lakes, squeeze into the St-Lambert locks daily. Just be patient. In fact, Queen Elizabeth II and President Eisenhower passed through the St-Lambert locks during its inauguration, aboard the royal yacht *Britannia*.

Take Route 132/20 to Exit 3 Est. Follow the signs for Écluses St-Lambert. There's a parking lot where you can wait, as well as a nearby bike path. Visit www.greatlakes-seaway.com for locations of vessels in transit.

A word of note: You do need clearance to take photos of the locks, and you'll also need to show ID. If you don't want to arrange this ahead of time, venture to nearby Parc Marie-Victorin for a shot of the ships on the St. Lawrence River, but at a distance. Parc Marie-Victorin is located along Chemin de la Rive near the Jacques Cartier Bridge access at Exit 8 along Route 132/20. The water shuttle mentioned in Chapter I also stops at Port de Plaisance of the Longueuil Marina along Parc Marie-Victorin.

Sépaq Parks/Îles-de-Boucherville National Park (55)

Quebec provincial parks and wildlife reserves are operated by La Société des Établissements de Plein Air du Québec, or Sépaq. The Sépaq banner encompasses two dozen parks, 20 reserves, and a dozen resorts and attractions. They are mentioned throughout this book. Sépaq parks come large and small, charge inexpensive entry fees, and many offer sports equipment rentals, such as kayaks and canoes. It's a wonderful resource if you wish to photograph Quebec's great outdoors. Call 1-800-665-6527 or visit www.sepaq.com.

About 6 miles from downtown Montreal you'll find Îles-de-Boucherville National Park,

a tranquil Sépaq park located in the middle of the St. Lawrence River.

Open year-round, the park offers well-marked trails for hikers and bikers, an observation tower, kayakers paddling the waterways, and plenty of wildlife that includes deer, foxes, and lots of mosquitoes. Colorful fall shots as well.

Take Autoroute 25 to Exit 1 near the Louis Hippolyte Lafontaine Tunnel.
Call 450-928-5088.

Cap-St-Jacques Nature Park/Anse-à-l'Orme Nature Park (56)

While these neighboring parks are operated by the city of Montreal, they offer a picturesque riverside feel.

Cap-St-Jacques (20099, Blvd. Gouin Ouest, Pierrefonds, 514-280-6871) combines a tranquil green space with lovely beach shots and views of Lac des Deux Montagnes. The site also features two historic houses and a working farm.

The nearby seasonal Anse-à-l'Orme (Chemin de l'Anse-à-l'Orme, 514-280-6871) offers a different angle of the lake and adds windsurfers to the frame. Lake view midafternoon shots may prove too bright and hazy for both parks, but the evening sunsets soften the frame.

Take Highway 40 (westbound) to exit 49 and follow the signs for either park.
Visit www.ville.montreal.qc.ca. Click Discovering Montreal, then Parks and Gardens.
Price: Parking costs about $7.

Exporail, the Canadian Railway Museum (57)

The photographic subject here: trains. Very big trains. Exporail is home to 150 Canadian-made passenger cars, freight cars, streetcars, and locomotives. You'll find natural lighting outdoors for about 100 of the trains, while the indoor pavilion holds about 50 cars. Unique shots offer a study of color, such as the bright red blade of the steam-operated rotary snowplow, or an atmospheric monochrome shot offering close-up details of the CPR 144, the oldest surviving Canadian-built steam engine. You may even be able to include one of the enthusiastic Canadian Railway Historical Association volunteers appropriately dressed in authentic engineer or conductor attire in the picture (that's how enthusiastic). The Museum Express offers a number of summer excursions from downtown Montreal to Exporail, by train, of course. The site is open daily spring through fall and weekends during winter.

At 110 Rue St-Pierre, St-Constant (Take Autoroute 15 south of Montreal to Exit 42).
Call 450-632-2410.
Visit www.exporail.org.

Area Festivals: International Balloon Festival of Saint-Jean-sur-Richelieu (58)

Pigs really do fly. The International Balloon Festival of Saint-Jean-sur-Richelieu floats into

Dragonfly at Cap-St-Jacques

town every August. And what a colorful, care-free, and fun photo op it is.

The festival, held since 1984, offers about 100 hot air balloons every year. On hand are the traditionally shaped varieties as well as special-shape balloons, which in the past have included a scarecrow, a bumblebee, a court jester, Darth Vader, an octopus, a snowman, and a flying pig named Hamlet.

Night Glows, one of the festival's most popular events, transforms the balloons into giant illuminated works of art. The Night Glows are usually scheduled three evenings during the 10-day festival.

Morning flights depart at 6 AM, but the balloons are dispersed among eight area parks. Your best photo op is during the evening flights, which depart at around 6 PM from the St-Jean airport. That said, the weather has to be on your side. The balloons only depart with light winds and no impending storm cells in the vicinity. The flights occasionally get cancelled due to unpredictable summer weather. But when the weather is on your side and all 100 balloons take flight, it's a sight to see and a photo to capture.

> At the St-Jean Municipal Airport. Take Autoroute 15 to exit at Route 219 and follow the signs.
> Call 450-347-9555.
> Visit www.montgolfieres.com.
> Price: About $15 for adults; parking fees extra. Balloon flights (per person) cost about $150 for weekday mornings, $195 for evenings and weekends.

Fort Lennox National Historic Site of Canada (59)

There's lots of history to capture at Fort Lennox.

It takes a short five-minute ferry hop on the Richelieu River to get to Île aux Noix, the is-land home of Fort Lennox. The island was the perfect place for a British fort, as it was close to the U.S. border (8 miles away); located on a natural transportation hub of the day, the Richelieu River; and linked two strategic bodies of water—the St. Lawrence River to the north and Lake Champlain to the south.

The British built the current fort between 1819 and 1829, and six original stone structures remain, including the officers' quarters, soldiers' barracks, guardhouse, prison, and ammunition magazines. The officers' quarters offers stately stone archways that let you play with perspective and shadows, while a sweeping green foreground and a bright blue sky add to the impact of any of the buildings. The ramparts offer a panoramic view of the river, perfect for a soldier way back when or a photographer today.

Inside the soldiers' barracks, rows of straw mattresses, redcoat uniforms, and storage boxes that display the actual names of members of the 24th regiment of the British army offer a unique perspective. Live costumed demonstrations are held weekends in July and August.

An on-site canteen offers snacks, or pack a picnic lunch. The site is open daily during the summer until Labor Day; weekends until Canadian Thanksgiving/Columbus Day. And the place is very well maintained. (That's what a Canadian National Historic Site moniker can do for you.)

The area also lends itself to picturesque shots of the countryside, farms, and the small marina.

> At 161st Ave., St. Paul de l'Île aux Noix, QC. About 20 minutes north of the U.S. border. Take Autoroute 15 to Exit 6 and follow the brown and white tourist signs.
> Call 450-291-5700.
> Visit www.pc.gc.ca/lhn-nhs/qc/lennox.
> Price: About $8.

Mount Orford National Park (60)

About an hour's drive east of Montreal is an Eastern Townships outdoor gem. Mount Orford National Park, a Sépaq park, offers well-marked hiking trails, lovely vistas, sloping hills, and gentle mountain terrain. Three seasons are best explored for shots of tranquil lakes in summer, foliage in fall, and a variety of sports in winter.

The Lac-Stukely sector is open year-round and offers a visitors center as well as equipment rentals, so depending on the season, the likes of kayakers and cross-country skiers are never far away.

The nearby Orford Arts Centre highlights a classical music festival every summer, as well as an Artistic Path, which combines a relaxing stroll through the woods with 20 outdoor sculptures. The nearby Mount Orford ski resort adds downhill skiing and snowboarders into the photo op, as well as a gondola ride that gets you to a great vantage point from which to capture fall foliage. The town offers iconic country village scenes as well as plenty of dining and lodging.

> Directions: Take Highway 10 to exit 188 in Orford. For the Orford Arts Centre, take road 141 through Mont Orford Park.
> Call 819-843-9855 (for the park); 1-800-665-6527 (for Sépaq).
> Visit www.sepaq.com or www.arts-orford.org.

St. Lawrence Seaway

Notre Dame des Victoires Church

VII. Upper Town: Downtown and the Montcalm City District; the Lower Town St-Foy Suburb

SPRING ★★ SUMMER ★★★★ FALL ★★★★ WINTER ★★

General Description: The sites listed here are all outside the walled portion of Old Quebec. Most are Upper Town downtown attractions. A few are located in the Lower Town suburbs.

Directions: If you're staying downtown (Loews Concorde, Delta, Hilton), or even at hotels in Old Quebec (inside the wall), you can walk to most of these sites. For the Aquarium, Quebec Bridge, Boulevard Champlain, and even the western portion of the Plains of Abraham and the museum, you'll need to drive or take a cab.

Parc Aquarium du Québec (61)

Operated by Sépaq, the Aquarium offers 10,000 specimens large and small, including resident walruses, seals, and two polar bears. The site is home to 300 species in all, both fresh- and saltwater creatures. A few species only a mother could love, as they rank as some

Where: Attractions located outside the walled fortifications

Noted for: Historical sites, grand government architecture, the changing of the guard, outdoor public art, and fish

Best Time: Spring through fall

Exertion: Minimal to moderate (for walking; sometimes uphill)

Parking: Public pay lots, metered street parking, hotel garage parking

Sleeps and Eats: Grande Allée offers two dozen plus restaurants and nightclubs in a busy party atmosphere. You'll also find the larger chain hotels here such as the Delta, Hilton, and Loews Concorde.

Sites Included: Plains of Abraham, Parliament Building, the Citadelle, Quebec Bridge

Area Tips: There's a bit of ground to cover, so divide your shooting time between Upper Town and Lower Town attractions.

Parc Aquarium Quebec City

of the most prehistoric things you've ever seen. The main tank, appropriately called Awesome Ocean, holds almost 100,000 gallons of water. You can get a great close-up view in the glass tunnel that runs underneath the tank—but the shot can be tricky, as no flash is allowed inside for all the aquarium tanks. In addition, there's often a crowd, so no tripods inside, either. That said, better close-ups without the flash are of the colorful fish that reside in the small saltwater tanks, as well as at the coastal zone, where you can reach out and touch the likes of a bright orange starfish or sea urchin.

Outside, the park features a small wetland area complete with marsh and footbridge, as well as a nice vantage point from which to capture the Quebec Bridge. The most fun shots of all: a yawning seal lounging in the summer sun or a content walrus enjoying an afternoon bristle-brush scrubdown given by one of the keepers.

> At 1675 Ave. des Hotels, Québec (under the Quebec Bridge).
> Call 418-659-5264 or 1-866-659-5264.
> Visit www.sepaq.com/aquarium.
> Price: About $16 for adults.

Quebec Bridge (62)

Quebec City boasts two bridges that span the St. Lawrence River from the south shore: the Quebec Bridge and the Pierre Laporte Bridge. The bridges run practically side-by-side, but the more interesting architecturally is the Quebec Bridge, which was designed in a cantilever style and opened in 1919 (in fact, this is the second Quebec Bridge—the first one collapsed during construction in 1907).

The Quebec Bridge offers a distinctive silhouette, and you can occasionally squeeze in a sailboat or two drifting along the St. Lawrence River in the foreground below. A variety of angles are easily had from all along Boulevard Champlain, mentioned next.

Boulevard Champlain (63)

Boulevard Champlain underwent a major overhaul in preparation for Quebec City's 400th anniversary in 2008—and rightly so. The thoroughfare, which connects the Pierre Laporte Bridge to the Old Port of Quebec, hugs the St. Lawrence River and offers spectacular views.

The renovated section, between the bridge and the Plains of Abraham Lower Town entrance, features a fun new sculpture park, a pedestrian and bike path, plenty of free parking, and lots of locals who come out in droves to ride their bikes or take an evening stroll along the river.

Musée National des Beaux-Arts du Québec (64)

Musée National des Beaux-Arts du Québec houses the provincial collection of fine art. You can visit for artistic inspiration, but photos are not allowed inside. That said, the museum's two historical buildings are definitely worth photographing.

The Gérard Morisset Pavilion, which was inaugurated as the sole museum space in 1931, offers grand neoclassical architecture with tall ornate columns. The neighboring Charles Baillairgé Pavilion is the former Quebec City prison, which opened in 1867 and was modeled after New York State's Auburn Penitentiary. For four decades, museum and prison stood side-by-side—about 300 feet away from each other—until the prison became obsolete during the 1970s, was shut down, and then transformed into museum space in 1991.

As the buildings are located on the grounds of Battlefield Park, you have lots of green space as well as a few outdoor sculptures to add to the foreground of your shots.

> Access the museum at Battlefields Park along Avenue Wolfe-Montcalm in the Montcalm district of the city, about a 20-minute walk from Parliament Hill along Grande Allée, or take Bus 11 to Grande Allée and Bourlemaque Street.
> Call 418-643-2150.
> Visit www.mnba.qc.ca.
> Price: Grounds access is free. Museum admission costs about $12 for temporary exhibitions; free for permanent collections.

Battlefields Park/Plains of Abraham (65)

Battlefields Park, also known as the Plains of Abraham, celebrated its 100th birthday in

2008. It was created to mark Quebec City's 300th anniversary a century before. This long narrow stretch of rolling green space overlooks the St. Lawrence River for almost 1 mile and encompasses about 270 acres. The Plains of Abraham was witness to many military sieges between the French and the British, the most notable clash during 1759, when the British finally infiltrated the French stronghold in a battle that lasted less than a half an hour.

Although the Battlefields Park Discovery Pavilion was ravaged by fire in winter 2008, there are still many subjects of note to photograph. Near where the pavilion once stood, you'll find the first glimpse of the rolling hills that adorn the park. The park's two Martello Towers, observation points once used by soldiers, add geometric shapes to the frame.

The small Joan of Arc Garden offers a centerpiece sculpture and a well-manicured flower garden—and the unique silhouette of the nearby Loews Concorde Hotel adds punch to the backdrop. And there are always a few folks to add to the mix, as the park is Quebec City's four-season playground. Subjects include costumed soldiers reenacting a New France military camp, and a horse-drawn carriage. In winter there are cross-country skiers, and thousands of revelers come Quebec Winter Carnival time.

Enter all along Ave. Wilfrid Laurier.
Call 418-649-6157.
Visit www.ccbn-nbc.gc.ca.

Capital Observatory (66)

On a clear day from the Capital Observatory you can see *pour toujours*—forever—or at least to Île d'Orléans, the St. Lawrence River, and even the Appalachian Mountains along the Quebec/Maine border. The observatory is located on the 31st floor of the Marie Guyart Building—that makes it the tallest point from which to see all of Quebec City. Interpretive

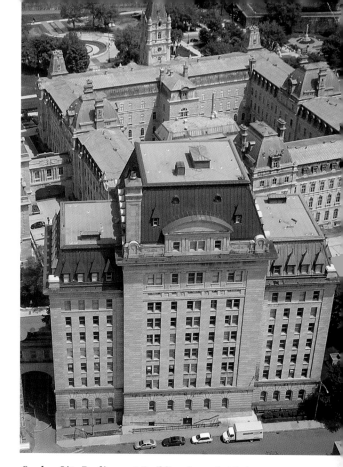

Quebec City Parliament Building from Capitol Observatory

panels along the way point out neighborhood landmarks and buildings, but if you do take shots, keep in mind that you're shooting through glass panels.

At 1037 Rue de la Chevrotière, Québec.
Call 418-644 9841 or 1-888-497-4322.
Visit www.observatoirecapitale.org.
Price: About $5.

Parliament Building and Tourny Fountain (67)

Government is big business in Quebec City, the capital of the province. And the city's buildings don't get any grander than this.

The center of Quebec government is at the

Parliament Building, home to 125 elected legislators of the National Assembly of Quebec. The building was constructed from 1877 to 1886 in the majestic Second Empire style of architecture. During the day, you can capture a variety of architectural details, such as the 22 bronze statues that commemorate important Quebec historical figures on the building's façade. Return in the evening to add the Tourney Fountain in the foreground to create a colorful night shot—don't forget the tripod. Save yourself some time to photograph this one. It's equally impressive and inspiring.

> In the Parliament Hill neighborhood near Grande Allée and Avenue Honoré Mercier.
> Call 418-643-7239.
> Visit www.assnat.qc.ca.

Palais Montcalm/Place d'Youville/St. Jean Gate (68)

Just before entering the walled confines of Old Quebec, you'll find a few neighboring landmarks worthy of capturing.

The Palais Montcalm is a modern theatre housed in a building that dates to 1932. In the foreground, Place d'Youville sometimes offers the solitude of a lone ice skater during winter, or a busy public square full of summer tourists. Just nearby is the famed St. Jean Gate entrance to the Old Town.

> At 995 Place d'Youville, Québec (for Palais Montcalm).
> Call 418-641-6040.
> Visit www.palaismontcalm.ca.

La Citadelle National Historic Site (69)

The Citadelle is the star-shaped fortress built between 1820 and 1850 as part of the British fortifications of North America. The Citadelle's rampart walls make it easy to practice and explore the photo concepts of line and perspective. You can walk along the exterior of the Citadelle from the western end of Dufferin Terrace and Rue St-Denis up the Cap Diamont hill, as well as near the main entrance off Rue St-Louis.

Visits inside are available by guided tour only, as the site remains an active military garrison. The Citadelle is home to the Royal 22nd Regiment, as well as the official residence of the Governor General of Canada.

During summer mornings, the regiment performs traditional changing of the guard ceremonies (weather permitting), which are accompanied by military band and Batisse, the company's resident mascot goat. Photos are allowed of the ceremonies and the grounds, but not inside the residence of the Governor General.

> At Côte de la Citadelle, Quebec.
> Call 418-694-2815.
> www.lacitadelle.qc.ca.
> Price: About $10.

Faubourg St-Jean Architecture/Points of Interest (70)

The St. Jean faubourg, or city neighborhood, bridges Upper Town and Lower Town. This residential area combines the typically steep streets for which Quebec is so well known and a maze of overhead power lines that create busy but inspiring photographic confusion. It's a wonder how these steadfast Quebecers make it uphill at all during wintertime. Be prepared to feel muscles in your legs you've never felt before. Also, be prepared to eat well—Rue St-Jean offers a variety of very good, affordable restaurants.

Where: Rue St-Jean from near Avenue Turnbull to Avenue Honoré Mercier and the surrounding side streets.

While You're in the Neighborhood—Other Historic Buildings and Area Festivals of Note: Music Conservatory of Quebec, Quebec City International Festival of Military Bands, Quebec Winter Carnival (71)

The office headquarters of the Music Conservatory of Quebec (225 Grande Allée Est) is a place that inspires musicians and photographers alike.

If you can't get enough of photographing a man or woman in uniform, the Quebec City International Festival of Military Bands held in late August is for you. Visit www.fimmq.com.

Finally, the annual Winter Carnival offers plenty of photo subjects, including two parades, dogsledding, canoe races on the frozen St. Lawrence River, and good old-fashioned winter fun for three weeks every January and February. The place goes nuts.

Visit www.carnaval.qc.ca.

Quebec City Parliament Building

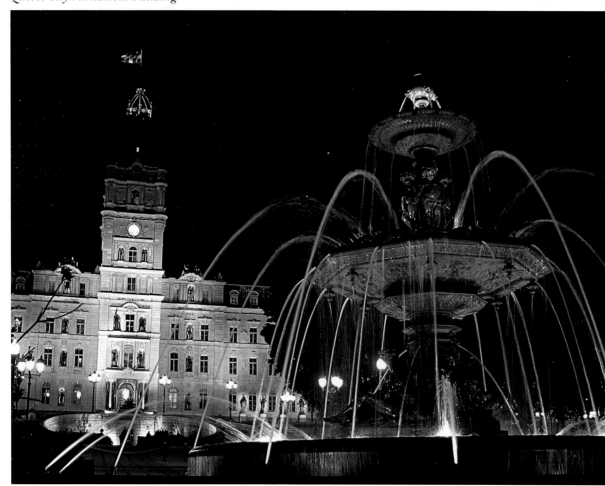

Quebec City, Dauphine Redoubt

VIII. Upper Town: Old Quebec

SPRING ★★★ SUMMER ★★★★ FALL ★★★★ WINTER ★★

General Description: I dare you not to include the Château Frontenac whenever you see it—it's just too irresistible.

Directions: From downtown, access the walled city—Old Quebec—at the St. Jean or St. Louis Gates.

Artillery Park Heritage Site/Fortifications of Québec National Historic Site/Dauphine Redoubt (72)

Artillery Park is a number of visits in one: the arsenal foundry, the Dauphine Redoubt, and the officers' quarters. The arsenal foundry is now an interpretation center that tells the history of the walled city.

The nearby Dauphine Redoubt is the

Where: Inside Quebec City's fortified walls

Noted for: Sumptuous New France architecture, lots of tourists, and perhaps the most photographed hotel in the world

Best Time: Spring through fall

Exertion: Minimal (a bit of walking)

Parking: An underground lot near City Hall, metered street parking

Sleeps and Eats: Plenty of both

Sites Included: Château Frontenac, Quebec Seminary, Rue Couillard

Area Tips: Ditch the car and walk. And be prepared to include many tourists in your photos during peak travel season. Or simply wake up before they do in the early morning hours—you'll practically have the whole area to yourself.

prominent, four-story white structure built in 1712 that houses vaults, barracks, and an English officers' mess hall. Capture it from the side facing downward on the grounds near the officers' quarters or from the lot below. It's striking from either view.

The location is the headquarters of the Fortifications of Quebec National Historic Site of Canada, better known as the walled part of the city. There are 2.9 miles of fortified wall in all. Self-guided tours and photo ops are available all along the wall, while the recommended guided tour retraces city history and explores a number of historic points along the way, including Dufferin Terrace, the Governors' Garden, Cap Diamont, and the Citadelle. The tour gives a nice introduction to the city and offers great panoramic views along the way.

> At 2 Rue d'Auteuil, Québec (Artillery Park).
> Call 418-648-4205, 888-773-8888.
> Visit www.pc.gc.ca/lhn-nhs/qc/artiller and www.pc.gc.ca/fortifications.

Notre-Dame de Québec Basilica-Cathedral (73)

Two fires have claimed the basilica-cathedral of Notre-Dame de Québec, but it has stood the test of time. The building site dates to 1647, and this newest cathedral was completed in 1925. The interior offers soft blue and cream ceiling frescoes and a breathtaking ornate golden-colored baldachin, a tentacled canopy

Quebec City Grand Seminary

that's positioned above the altar. It's worth a close-up, but I like the shot in a long perspective. No flash or tripods inside, but you can use a pew to help secure the camera and enough light filters in from the windows above. Outside, it's almost a double take to see the bronze rooftop, an actual shade of dark brown in a city of green oxidized roofs. The roof and steeple were replaced in 2007.

> At 16 Rue de Buade, Québec.
> Call 418-692-2533 (Rectory).
> Visit www.patrimoine-religieux.com (this Web site offers a thorough overview of Quebec City-area churches).

Séminaire de Québec/Musée de l'Amérique Française (74)

With its off-white exterior and a crisp blue sky, the Quebec Seminary is a superb study of clean lines, architectural composition, and perspective. The site was founded by Monseigneur de Laval in 1663 and remains a working school today.

I prefer the main courtyard exterior shots in the afternoon—you'll get more of the seminary than of the museum with the light to your advantage. That said, you can capture a new angle any time of day—just make your way through the courtyard toward a side entrance along Rue des Ramparts, the street lined with authentic cannons. As mentioned before, the space is still a working school, so be considerate when the students take recess in the courtyard. The seminary also makes an impressive skyline subject from the Old Port's Louise Marina.

The adjacent Musée de l'Amérique Française has the distinction of being the oldest museum in Canada. The museum offers an

Rue Couillard

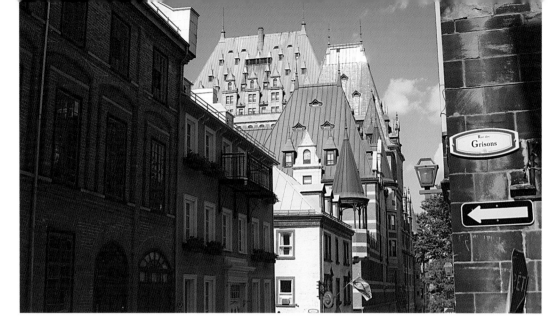

View of Château Frontenac from a side street

impressive collection of fine art, religious artifacts, and scientific instruments, and thoughtfully explores the history of the French language in North America. Interior shots of the museum are prohibited, but you can take interior photos of the on-site chapel, which today is used as a community hall.

At 2 Côte de la Fabrique, Québec (for museum and courtyard entrance).
Call 418-692-2843.
Visit www.mcq.org.
Price: A courtyard walk-through is free. Museum admission costs about $10.

Rue Couillard/Musée Bon-Pasteur (75)

Rue Couillard is my favorite street to photograph in Quebec City. It will be yours as well.

This narrow street meanders along Old Quebec for a short stretch and offers traditional New France architecture, playful perspective, and unique photo challenges.

For one, the lighting on a sunny day (and the shadows cast by the buildings) can wreak havoc with exposure levels; try a number of settings, embrace the shadows, or if you've the time, wait for an overcast day to balance out the lighting. And depending on whether you want people in your shot, you'll need to be a bit patient. While much quieter compared to its Rue St-Jean neighbor, Rue Couillard is busy enough that as soon as someone ducks down one side street, another visitor enters the frame from a different direction. But sometimes that single passerby adds the perfect element to the shot. The sidewalk café Le Temporal adds a relaxed atmosphere of *joie de vivre* to the photo—as well as good coffee and croissants.

The Bon-Pasteur Museum provides the perfect central focal point from which to capture the street from the corner of Rue Hamel. This small museum tells about the congregation of the Sisters of Bon-Pasteur, who oversaw a refuge for troubled women and abandoned children during the 19th and 20th centuries.

This street will surely inspire your photographic muse.

At 14 Rue Couillard, Québec (museum).
Call 418-694-0243.

Château Frontenac (76)

The Château Frontenac is said to be the most photographed hotel in the world. It is indeed the center of the Quebec City universe, and for good reason: it's majestic and beautiful, it's steeped in history, it offers a touch of class, and it's never far from the eye of any tourist or local.

The Château was built as a luxury stopover when the Canadian Pacific Railway joined one end of Canada to the other. Back in the late 1800s, it took five days to travel by train from one side of Canada to another. But the train could not accommodate passengers overnight. The solution: build a string of hotels along the way where the passengers could lodge. CP built its first hotel in Banff in 1888; the Château Frontenac was the second property in the CP family—the location was perfect, as Quebec was the first stop in Canada for cruise ships arriving from Europe. The hotel officially opened its doors in 1893, but the trademark tower wasn't added until the 1920s. Famous guests have included Paul McCartney, Celine Dion, Queen Elizabeth II, and Alfred Hitchcock. President Franklin D. Roosevelt, Prime Minister Winston Churchill, and Canadian Prime Minister Mackenzie King met at the Château Frontenac to discuss plans for the D-Day invasion during the Second World War.

In no particular order, here are some of my favorite vantage points from which to capture the Château Frontenac.

From Upper Town:

- The surrounding side streets near Rue Mont Carmel and Rue des Grisons
- Inside looking out on the guided tour
- From Pierre Dugua de Mons Terrace on Ave. St-Denis
- Along Dufferin Terrace
- From the Citadelle
- With a calèche parked in front

From Lower Town:

- Aboard the Quebec City to Lévis ferry
- The Old Port along Boulevard Champlain/Rue Dalhousie (near the ferry)
- The Old Port along the streets that surround the Quebec Funicular
- Parc Montmorency (near the main post office)

If you're not staying at the hotel, you can still take a fun guided tour for about $10. Taking photos is allowed during the tour. You may not have time to set up a tripod, but you can capture some quick shots of the famous peaked green roof from the inside looking out, with the St. Lawrence River or Dufferin Terrace as your backdrop.

> At 1 Rue des Carrières, Québec.
> Call 418-692-3861, 1-888-274-0404 (hotel).
> Call 418-691-2166 (tour). The tour runs daily from May to mid-October; weekends during the rest of the year. Reservations required.
> Visit www.fairmont.com/frontenac.

Dufferin Terrace/Saint-Louis Forts and Châteaux National Historic Site of Canada (77)

Dufferin Terrace is the landmark promenade at the foot of the Château Frontenac that overlooks the St. Lawrence River. The terrace was named for Lord Dufferin, who saw to the preservation of Quebec City's walled fortifications.

Supervised by Parks Canada, in recent years the terrace has become a working archaeological site, where scholars have unearthed the remains of the first Château St-Louis, the home where Samuel de Champlain lived until his death in 1635.

If you need to practice shots of perspective, walk to the "west" end of the terrace, face the

Château Frontenac, position the Château into the left side of the frame, and add strolling tourists to the foreground. Perspective problem solved!

Call 418-648-7016.
Visit www.pc.gc.ca/lhn-nhs/qc /saintlouisforts/

While You're in the Neighborhood—Other Historic Churches of Note: Jesuit Chapel, Musée des Ursulines, L'Hôtel-Dieu (78)

The Jesuit Chapel (20 Rue Dauphine, 418-694-9616) stands tall near the fortified wall. The surrounding street seems to drop off into oblivion if you capture it just right.

The Musée des Ursulines (12 Rue Donnaconna, 418-694-0694) and its neighboring chapel offer the history of the congregation of the Ursulines, who arrived in Quebec City in 1639. While no photography is allowed inside, exterior shots of the congregation's buildings should keep you busy.

The Augustine congregation came to town in 1639 and established l'Hôtel-Dieu, Quebec City's first hospital. The chapel, hospital, and a grand mural offer architectural and colorful inspiration on Rue Charlevoix and Côte du Palais.

While You're in the Neighborhood—Other Historic Buildings and Attractions of Note: Restaurant Aux Anciens Canadiens, Clarendon Hotel, Price Building, Rue du Trésor (79)

Restaurant Aux Anciens Canadiens (34 Rue St-Louis, 418-692-1627) offers authentic Quebecois-style cuisine in a house that dates to 1675—said to be the oldest house in the city. You can't miss is—just look for the bright red roof.

Clarendon Hotel (57 Rue Ste-Anne, 418-692-2480) is one of the most beautiful hotels in the city—and the oldest as well. Its operation as a hotel dates to 1870. Art deco style reigns here,

Jesuit Chapel

evident in the clean lines on the façade, the heavy doors made of glass and iron, and a most elegant front desk in town, complete with marble counter and ornate wood and iron accents.

Just next door, you'll find the 18-story Price Building (65 Rue St-Anne). It dates to the early 1930s and is the oldest skyscraper in Quebec City.

Rue du Trésor, in the shadow of the Château Frontenac, boasts an alley full of artists selling their wares for that symbolic travel shot.

IX. Lower Town: Old Port and St-Roch

SPRING ★★★ SUMMER ★★★★ FALL ★★★★ WINTER ★★

General Description: The Lower Town offers some of the oldest architecture in the city, an up-close view of the St. Lawrence River, and the residential St-Roch neighborhood.

Directions: From Old Quebec, take the funicular to Place Royal and the Old Port below, or walk downhill along Côte de la Montagne. You can also start the tour in St-Roch by accessing the outdoor staircase or elevator located in Upper Town's St-Jean neighborhood.

Quebec Funicular (80)

The easiest way to get from Lower Town to Upper Town, or vice-versa, is on the funicular. Accessed at Dufferin Terrace from above and at Petit Champlain Street from below, the funicular has helped Quebecers and tourists up and down the 200-plus-foot cliff since 1879. It's only a two-minute ride and sometimes crowded, so you'll have to be quick with the camera.

Quebec City funicular

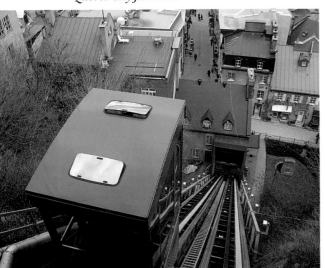

> **Where:** The Lower Town near the St. Lawrence River
> **Noted for:** Where Quebec City was first settled
> **Best Time:** Spring through fall
> **Exertion:** Minimal to moderate (minimal for walking; moderate when you're walking uphill—or downhill)
> **Parking:** Metered street parking. Pay lots are located on Rue Dalhousie near the ferry and at the Old Port Market.
> **Sleeps and Eats:** Many throughout the area. Le Port Royal Hotel and Dominion 1912 Hotel are recommended stays in the Old Port. Le Café du Monde is a great Old Port eatery. Pur Hotel offers minimalist style, while Les Bossus is a casual French bistro, both in St-Roch.
> **Sites Included:** Quartier Petit Champlain, Louise Marina, Notre Dame des Victoires Church
> **Area Tips:** In winter, be careful of melting ice and snow that slides off the building rooftops along the narrow Old Port streets— downright dangerous at times.

Practice perspective shots from below by squeezing in street scenes, the funicular, and a portion of the Château Frontenac.

At 16 Rue Petit Champlain, Québec. Call 418-692-4415. Visit www.funiculaire-quebec.com. Price: About $2.

Quartier Petit Champlain (81)

Located near the funicular's Lower Town entrance, you'll find Quartier Petit Champlain and Rue du Petit Champlain, one of the oldest sections and streets in the city. Some of the historic houses that line the street date to the late

Old Port building, Quebec City

1600s. Today, the quarter is lined with dozens of restaurants, souvenir shops, and lots of visitors. It's often too many people to contend with if you're trying to photograph the area, but sometimes it's the close-up photo of a souvenir display that captures the true essence of this touristy street.

Some of the side streets make for a great vantage point from which to capture the Château Frontenac from a very steep angle. Rue Sous le Fort is one of them, although it can be quite busy. Instead, walk one block to Rue Notre Dame and Rue du Cul-de-Sac to capture the Château with plenty of iconic New France architecture in the foreground. In fact, one time when I photographed the Château from this spot, I had the corner all to myself. I set up the tripod, looked into the viewfinder, and adjusted my settings. When I looked up, I was surrounded by tourists who must have thought: "Hey, this guy's got a tripod, he must know what he's doing!" Well, there's plenty of the Château to go around for every photographer! Snap away!

Visit www.quartierpetitchamplain.com.

Notre-Dame-des-Victoires Church/ Place Royale/Mural (82)

Notre-Dame-des-Victoires Church dates from 1688 and stands as the oldest stone church in North America. As the Place Royale cobblestone square gets packed with tourists, a perfect time to capture the church exterior is in the evening, when many folks are having dinner. Bring the tripod. The interior features the suspended scale model ship *Le Brézé,* whose real-life counterpart arrived in New France with contingents of French soldiers in 1664. While a popular tourist spot, the church remains an active place of worship and flash photography is not allowed inside.

The front courtyard, Place Royale, is the very place where Samuel de Champlain established the Quebec settlement in 1608, as well as two fortified residences during the 1620s. The first version of the bust of Louis XIV was installed in 1686.

A colorful, detailed mural of New France life painted on a building wall near the intersection of Rue Notre Dame and Côte de la

Old Port skyline along Rue Dalhousie

Quebec City main post office from Lower Town

Montagne provides a fun optical illusion. If you're lucky, a resident accordion player or musician will add to the mix.

At 32 Rue Sous le Fort, Québec (church). Call 418-692-1650. Visit www.patrimoine-religieux.com.

Québec-Lévis Ferry and *Louis Jolliet*/AML Cruises (83)

The area's St. Lawrence River boat excursions not only take you to great places to photograph, but the ships also highlight the city's rich maritime heritage and are worthy of photographing in their own right.

The Québec to Lévis ferry operates year-round and takes 10 minutes to travel the half-mile to the south shore. The ferry service runs from 6 AM to 2 AM. It's the perfect mini-cruise and the perfect vantage point from which to capture the Château Frontenac and the Quebec City skyline with the St. Lawrence River in the foreground. Take an early morning cruise to capture the skyline with the sun at your back. In addition, a visiting luxury cruise liner is sometimes docked at the Old Port. The roundtrip costs about $5.

Quebec's iconic *Louis Jolliet* is synonymous with St. Lawrence River cruises. Day cruises visit the Quebec Bridge, Montmorency Falls, and Île d'Orléans, while night cruises offer views of the fireworks at Montmorency Falls. Food-themed cruises include a Sunday

Musée de la Civilisation

brunch buffet and an evening dinner cruise. The *Louis Jolliet* departs from the Chouinard Pier along Dalhousie Street. Cruises start at about $30.

> Québec-Lévis Ferry
> At 10 Rue des Traversiers, Québec.
> Call 418-643-8420 or 1-877-787-7483.
> Visit www.traversiers.gouv.qc.ca.

> *Louis Jolliet*/AML Cruises
> At 124 Rue St-Pierre, Québec.
> Call 1-800-563-4643.
> Visit www.croisieresaml.com.

Musée de la Civilisation (84)

The innovative Musée de la Civilisation pays tribute to a variety of world cultures. With 11 exhibition spaces, there's a little something for everyone. Permanent exhibitions include "People of Quebec . . . Then and Now," a fascinating and thorough history from New France to the present. As with many museums, photos

are not allowed inside. Not to fret, the fun photo op is outdoors.

The building represents fairly new digs in Old Quebec—the museum celebrated two decades in 2008, and was designed and integrated with the Old Port's rich heritage in mind. The space incorporated existing structures as well as added elements of steel, stone, and a trademark glass steeple. A terraced staircase lets you traverse the building from Rue Dalhousie to the rear of the building on Rue St-Pierre. Its peaked green roof makes for a colorful exploration of geometry and sky.

> At 85 Rue Dalhousie, Québec.
> Call 418-643-2158, 1-866-710-8031.
> Visit www.mcq.org.
> Price: About $10.

Louise Marina, Bunge Grain Silos, Espace 400e (85)

Espace 400e hosted many 400th anniversary events and is now an interpretation center that

St. Paul Street in the Old Port

displays an exhibition about immigration. The site, which features a connecting promenade that traverses the waters of the Louise Marina, makes for a unique foreground element to the skyline in one direction, and offers a Quebec-style industrial architecture with a view of the 1,000-foot-long Bunge grain silos in the other direction. Add rows of sailboats to complete the nautical-themed frame.

Access along Rue St-Andre.

Streets to Stroll (86)

As with Old Quebec, the camera won't stay in the bag for long—that's how inspirational and photogenic the architecture and streets of the Old Port are.

Rue St-Paul offers dozens of well-worn an-tiques shops, complete with steadfast clients and lots of tourists.

Lower Town's Rue St-André near Espace 400e offers a great view upward of the Quebec skyline and Upper Town's Rue des Remparts. It's best in late spring when the trees are not in full bloom.

The busy intersection where Rue St-Paul, Rue St-Vallier Est, Côte Dinan, and Côte de la Canoterie converge near Hotel des Coutellier (253 Rue St-Paul, 418-692-9696) creates a fun perspective, where inclined streets meet rows of Old Port architecture.

Area Festivals: New France Festival (87)

You only have a small window of opportunity to photograph the annual New France Festival

La Caserne

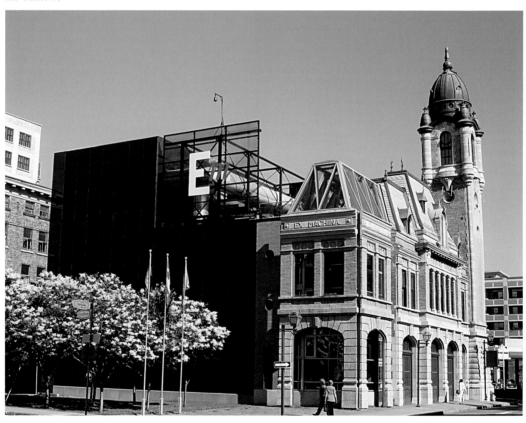

—Les Fêtes de la Nouvelle-France—as it takes place for five days in early August. But what a fun photo op it is. Here you'll find thousands of Quebec City residents decked out in colorful, authentic New France garb who are all most willing to pose and smile for the camera—their spirit and camaraderie are infectious. The costumes complement the city's architecture so well that you'll truly feel as if you have stepped back in time. Other fest photo ops include military parades and the Meeting of the Giants, a march of giant effigies in the style of European street fairs.

Held in Old Quebec and the Old Port. Visit www.nouvellefrance.qc.ca.

While You're in the Neighborhood—Other Historic Buildings of Note: La Caserne, Hotel Dominion 1912, St-Paul Hotel, Old Port Market (88)

La Caserne (103 Rue Dalhousie)—the home of Quebec favorite son, artist Robert Lepage and his Ex Machina visual arts and performing studio—is housed in a former firehouse near the Musée de la Civilisation.

The ritzy contemporary Hotel Dominion 1912 (126 Rue St-Pierre, 418-692-2224) puts the boutique in boutique hotels. It's modern on the inside and, as the former stock exchange building, historic and charming on the outside.

Le St-Paul Hotel (229 Rue St-Paul, 418-694-4414) offers a unique angled façade complete with shiny tin roof. Reasonable stays as well.

Finally, the Old Port Market adjacent to the train station isn't old in terms of architecture, but it does offers healthy snacks and many good things to eat.

Gare du Palais Train Station (89)

Quebec City's train station, the Gare du Palais, is often mistaken for its next-door neighbor, a government building and post office.

Gare du Palais Train Station

Each offers a château-style design, peaked copper roofs oxidized green with age, and a modern sculptural fountain in the foreground. And both are worthy of photographing. The interior of the train station also offers a colorful stained glass mosaic of a map of Canada.

At 450 Rue de la Gare du Palais, Québec.

St-Roch Garden (90)

Nothing more than a vacant lot about a decade ago, Jardin de St-Roch, a small urban garden, has become the symbol of a neighborhood's

St-Roch Garden

revitalization. The park, now surrounded by office space, is two blocks from the bustle of Rue St-Joseph.

The shot from the Upper Town staircase is the obvious one. Instead, opt for a playful close-up of the garden's trademark line of shrubs, fountain waterfall, and mod art deco-style corner lighting. Another nearby choice, with its steady incline, is the Upper Town/Lower Town border street Rue St-Vallier, which offers a fun exploration of perspective as far as the eye can see.

Where: Bordered by Rue de la Couronne, Rue St-Vallier Est, Rue du Parvis, and Rue Ste-Hélène.

St-Roch Neighborhood and Architecture (91)

With street improvements such as the removal of a pedestrian mall, as well as the arrival of fine dining and shopping, St-Roch is definitely coming into its own. There are plenty of residential architectural gems to photograph throughout the side streets of St-Roch, complete with many overhead telephone lines. In addition, there are dozens of wonderful places to eat along Rue St-Joseph near the street's centerpiece St-Roch church. If you're arriving via the Old Port near the train station, the Highway 440 overpass murals where the Old Port's Rue St-Paul meets St-Roch's Boulevard

Charest make for a colorful and fun exploration of line and perspective, with the Quebec City skyline in the distance.

Cartier-Brébeuf National Historic Site of Canada (92)

The Cartier-Brébeuf park area along the St. Charles River marks the landing site where Jacques Cartier and his shipmates spent the winter in 1535–1536. The site offers a monument and cross to commemorate the event, as well as a small interpretive center that offers tours of the area. A riverbank stroll on your own is most easily accessed near Rue du Prince Edouard in St-Roch. The riverbanks were renovated with natural plants and a bike path in time for the city's 400th anniversary in 2008. It's a tranquil space, complete with a gentle winding river that makes for a lovely nature shot less than a 15-minute walk from the train station. To further explore the area, visit the Société de la Rivière St-Charles interpretation center/historic house (www.societerivierest charles.qc.ca) near the Cartier-Brébeuf site for maps and a display of vintage photographs.

At 175 Rue l'Espinay, Québec.
Call 418-648-4038.
Visit www.pc.gc.ca/lhn-
 nhs/qc/cartierbrebeuf.

Along the St. Charles River in St-Roch

Grosse Île and the Irish Memorial National Historic Site of Canada

X. Side Trips

General Description: Nature and outdoor sports photographers to the front of the line.

Directions: From Quebec City, take 40 west to get to Station Touristique Duchesnay. Take Highway 138 east for Montmorency Falls and the Beaupré region. You can also take the King's Road for a glimpse of 17th-century structures (although there are not many places to pull over and park).

Montmorency Falls (93)

About a 15-minute drive from downtown Quebec is all it takes to capture some dramatic nature shots at Montmorency Falls, which cascades an impressive 240 feet from the Montmorency River above to the St. Lawrence River below.

From below, capture the falls from the interpretive center at the main parking lot. From above, shots are available along the pedestrian suspension bridge that hovers directly over the falls near Manoir Montmorency, as well as on-site hiking trails and belvederes. Take the cable car for a unique vantage point, or use it as a foreground subject in your shots.

Montmorency Falls becomes the perfect backdrop for six spectacular fireworks shows held in July and August. Be prepared for a crowd any time during summer. In winter, the subject at hand includes intrepid ice climbers ascending the fall's frozen façade.

> At 2490 Ave. Royale, Québec (mailing address). Take Autoroute 40 east or Boulevard Ste-Anne, Highway 138, east and follow the signs for Chute Montmorency.
> Call 418-663-3330 or 1-800-665-6527.
> Visit Sépaq at www.sepaq.com and

Where: A number of parks, ski resorts, and natural attractions north and east of Quebec City, most within a 45-minute drive.

Noted for: Pristine green spaces, pastoral farm settings, dramatic waterfalls, historic church shrines, and St. Lawrence River cruises

Best Time: Spring through fall

Exertion: Minimal to moderate (for walking and hiking)

Parking: On-site parking available at most sites mentioned.

Sleeps and Eats: Plenty of specialty food purveyors and B&Bs on Île d'Orléans. An auberge, cabins, and an Ice Hotel are available at Station Touristique Duchesnay. There are many *casse-croute* (sandwiches, burgers, and fries) types of eateries along the way. Better still, pack a picnic lunch.

Sites Included: Montmorency Falls, Île d'Orléans, Canyon Ste-Anne, St. Anne de Beaupré Shrine

Area Tips: Don't try to tackle all these in one day.

> www.lesgrandsfeux.com for fireworks info.
> Price: About $10 for parking; $11 for optional cable car access.

Île d'Orléans (94)

The earliest New France settlers established themselves at Île d'Orléans beginning in the 1630s. The island's pastoral farmland provides Quebec with many good things to eat, as well as beautiful landscape photography.

There are only two main roads—one that runs along the perimeter and one that bisects the island in two. You don't have to drive too far for some wonderful, picturesque shots of

dilapidated or brightly painted barns, New France–era houses (now protected by heritage laws), fields of crops, and churches that date to the mid-1700s. There's not much space off the side of the road for parking, but I was able to sneak into a driveway here and there without a complaint from any homeowner (or curious horse). Points of interest in the Ste. Famille parish (there are five parishes in all) include a church that dates from 1749 and Site Patrimonial et Historique Maison de Nos Aïeux, a small museum that offers artifacts and genealogy information about the island's residents (turn left at the first intersection after the bridge and drive about 10 minutes). A diffuser filter comes in handy to reduce the glare of those shiny New France building rooftops. If you want to capture food purveyors in action, choose from cheese makers, a chocolate factory, vineyards, cider producers, sugar shacks, a microbrewery, and pick-your-own farms.

Take Autoroute 440 or Route 138 east from Quebec City to the Île d'Orléans Bridge (Pont de l'Île).
Call the Île d'Orléans Tourist Information Center at 418-828-9411 or 1-866-941-9411.

Ste. Anne de Beaupré Shrine (95)

Ste. Anne de Beaupré celebrated a milestone 350th anniversary in 2008. The shrine dates from 1658 and is considered the oldest pilgrimage site in North America. The present basilica was built in 1923. It's the fifth church to be erected on the site.

The exterior offers magnificent spires, grand columns, and little by way of obstructions. I once photographed it with some very

Île d'Orléans barn

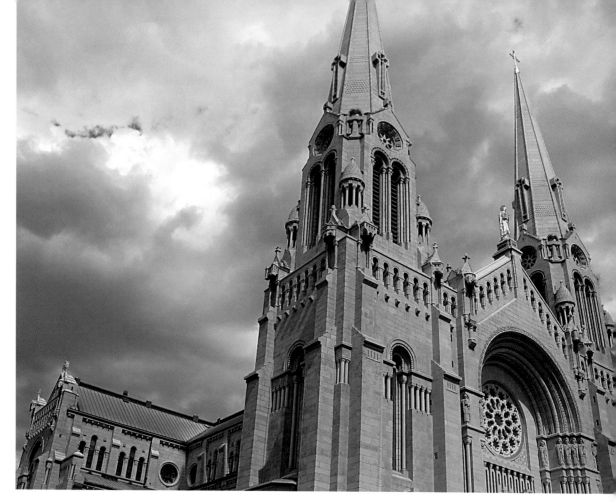

Ste. Anne de Beaupré Shrine

ominous-looking clouds in the sky, which added some drama to the majesty of the shot. The interior architectural details include hand-carved pews and a mosaic on the life of Ste. Anne. Flash is not permitted inside, and be thoughtful of those who come to worship.

If you're taking Route 138 east, there are a number of roadside antiques store shots that are yours for the taking. You can also take the King's Road between Montmorency Falls and Beaupré. The Ste. Anne's church spires loom in the distance along this narrow street as you get closer to town, but as mentioned before, there are not many places to pull over and park.

In Ste. Anne de Beaupré, QC (just follow the signs).
Call 418-827-3781.
Visit www.ssadb.qc.ca.

Mont Ste-Anne (96)

Winter skiing, summer mountain bike tournaments, and fall foliage highlight the photographic subjects to be found at Mont Ste-Anne. Spring through fall, the mountain offers panoramic gondola rides for about $15 round trip. The iconic fall foliage event is called Great Color Adventure. It runs from mid-September to mid-October.

Cap Tourmente farmhouse

At 2000 Blvd. du Beau Pré, Beaupré, QC.
Take 138 east and follow the signs.
Call 418-827-4561 or 1-888-827-4579.
Visit www.mont-sainte-anne.com.

Cap Tourmente National Wildlife Area (97)

Cap Tourmente National Wildlife Area is a pristine piece of property that hugs the north side of the St. Lawrence River. The marshlands provide vibrant greens, big sky, and impending afternoon summer storms if you time it right.

Environment Canada established the reserve to protect the American bulrush, a perennial grass that happens to be a favorite food of greater snow geese, which number in the thousands come the spring and fall migrations. In all, the site is home to some 300 species of birds, including the great gray owl, peregrine falcon, and ruby-throated hummingbird. The location also lays claim to regional history, as Samuel de Champlain built the area's first farm there in 1626.

The site includes an interpretation center, an observation tower, and about 12 miles of hiking trails. A word of warning: the snow goose hunt takes place in fall. The wildlife area is open from mid-April to the end of October and early January to mid-March.

I visited only once, but got to the reserve near closing, though there was enough remaining daylight. I nonetheless took some shots of the farmhouse/interpretation center as well as the marshland riverbank, a short drive away near the Laval farmhouse. While near the marshland, a dramatic summer storm approached. I made it to the riverbank, took some photos, and ran like heck back to my car to beat the torrents of rain. It was worth the trouble to get the shot!

At 570 Chemin du Cap Tourmente in St.
Joachim, QC. From Ste. Anne de
Beaupré, take 138 east a short distance
and follow the tourist signs.
Call 418-827-4591.
Visit Environment Canada at www.qc
.ec.gc.ca (click Search, Nature, Eco-
systems and Habitats, National Wildlife
Areas: Quebec).

Canyon Ste-Anne (98)

Very user-friendly, Canyon Ste-Anne offers a lush green landscape and a dramatic 240-foot waterfall. On a sunny day, a rainbow is never far away. In addition, the bright red helmet of a mountain climber offers a splash of color against the wet, gray rocks, as well as perspective of size. Three pedestrian bridges let you traverse the canyon with relative ease, and all trails are clearly marked. Take note of one trail—and specifically its 187-step descent to the lower bridge. Those steps are the only way back up, but landings along the way let you take a break if you're carrying lots of gear. The site has also inspired other artists, including Henry David Thoreau, who visited in 1850, and Cornelius Krieghoff, who painted the falls in 1855. Depending on the time of year and the force of the water, at certain points along the trail you may have to protect your equipment from the spray of the falls.

At 206 Route 138 Est, Beaupré, QC.
Call 418-827-4057.

Visit www.canyonste-anne.qc.ca.
Price: About $10.

Jacques-Cartier National Park, Station Touristique Duchesnay and the Ice Hotel (99)

It only takes a 25-minute drive north of Quebec City to lead you into the Laurentians Mountain range and the pristine wilderness of Jacques-Cartier National Park. This Sépaq park offers an information center and well-maintained roads for the first 10 miles (15 kilometers). After that you drive along a gravel road that's equally well-maintained, but a bit bumpy. Moose are sometimes spotted between kilometer markers 17 and 19. I didn't see any moose, but on a well-marked trail that hugs the river, I did spot some hoof marks among the hiking boot and mountain bike imprints. Nonetheless, a number of pedestrian bridges along the way offer a good vantage point from which to take shots of outdoorsy types who canoe and kayak their way down the Jacques Cartier River. The shaded summer forest makes for a serene exploration of green, from abundant tree leaves to moss covering downed trunks. Come autumn, the place is ablaze with color. Canoe and kayak rentals are available if you wish to take the perspective from the water, and that means waterproofing your gear.

Directions: Take Route 175 North.
Call 418-848-3169 (summer), 418-528-8787 (winter).

Climbers by Canyon Ste-Anne

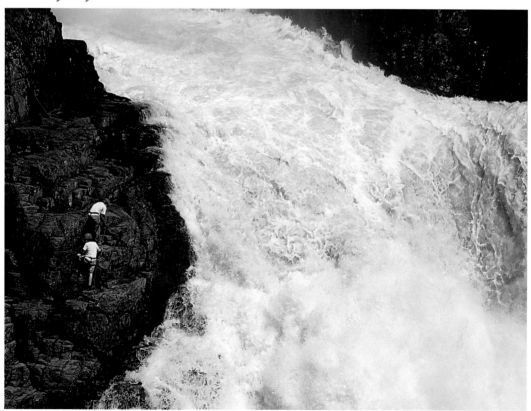

In Jacques-Cartier National Park

About 30 miles west of Quebec City, Station Touristique Duchesnay offers four seasons of outdoor adventures. Here you can capture sports shots such as fishing in summer and dogsledding and cross-country skiing in winter. There are a variety of accommodations onsite, including an auberge, log cabins, a spa, and the Ice Hotel, which is open from January to the beginning of April.

The Ice Hotel offers abstract photographic explorations of ice and color. Don't forget to adjust your F-stop when capturing all that white snow (try a stop lower). Accommodations at the Ice Hotel don't come cheap—weekend rates start at about $500 a night. But you don't have to stay overnight. A visit with cocktail and transportation from Quebec City costs about $50.

Both at 143 Route Duchesnay, Ste. Catherine de la Jacques Cartier, QC. Take Highway 40 West.
For Station Touristique Duchesnay, call 418-875-2122 or 1-877-511-5885.
For the Ice Hotel call 418-875-4522 or 1-877-505-0423.

Grosse-Île and the Irish Memorial National Historic Site of Canada (100)

Grosse-Île and the Irish Memorial National Historic Site offers a serene green space and a well-preserved solemn trip back in time. Some 30 miles east of Quebec City on the St. Lawrence River, Grosse-Île commemorates Quebec's role in Canadian immigration, the island's role as a quarantine station from 1832 to 1937, and the tragedy of the deaths of about

5,000 Irish immigrants at sea due to the 1847 typhus epidemic.

The island features almost three dozen mid-19th-century and early 20th-century buildings to capture in a tranquil pastoral setting, among them medical buildings used for vaccinations and examinations; a bakery and kitchen; and three hotels ranked by first, second, and third class. Other points of interest include the majestic Celtic cross monument and the Irish Cemetery.

There's a bit of ground to cover if you have lots of gear, but a tourist trolley helps you get around. Fall foliage peaks from September to closing. In addition, wide-angle St. Lawrence River views are readily available all along the boat trip. Allow seven hours for the cruise and visit.

The mailing address is 2 Rue d'Auteuil, Québec (Fortifications National Historic Site of Canada).

Call 418-234-8841 or 1-888-773-8888.

Visit www.pc.gc.ca/grosseile.

Price: Admission costs about $18. Boat transportation on Les Croisières le Coudrier from Quebec City's Old Port costs about $65. Or take a 40-minute drive to Berthier-Sur-Mer on Quebec's south shore along Autoroute 20 Est and take the ferry aboard Les Croisières Lachance (www.croisiereslachance.ca; 418-259-2140).

Grosse Île shoreline and Celtic cross

Palais des Congrès, Montreal

Practical Travel Info

Traveling to Canada: Proper Travel Documents

The U.S. Department of Homeland Security and Citizenship and Immigration Canada are pretty much in cahoots when it comes to necessary travel documentation.

Canadian law requires that everyone entering Canada present both proof of citizenship and proof of identity. For U.S. citizens, a valid passport, passport card, or NEXUS card satisfy this requirement. Also, as of June 1, 2009, all U.S. citizens who enter Canada must present a valid U.S. passport, passport card, or NEXUS card in order to enter or reenter the United States, whether they are traveling by land, sea, or air. A visa is not required for U.S. citizens traveling to Canada. The requirements and dates change often, so keep checking the government Web sites.

Visit Citizenship and Immigration Canada at www.cic.gc.ca
or call 1-800-622-6232.

Also visit U.S. Citizenship & Immigration Services at www.uscis.gov, the Department of Homeland Security at www.dhs.gov, and the U.S. Department of State at www.travel.state.gov
or call 1-800-333-4636.

Canadian Customs

For information on what you can and cannot bring into Canada, visit www.cbsa-asfc.gc.ca. You can also call Border Information Services, BIS, at 204-983-3500 or 506-636-5064.

As for expensive camera equipment, a copy of your receipt comes in handy to prove the origin of purchase.

Return Trips to the U.S.

Items purchased in Canada must be declared at the U.S. border, and some restrictions apply. It's a good idea to pack purchases separately and have them ready to show if asked. Save your receipts and keep them handy as well.

For information of what's allowed back into the States, visit Know Before You Go on the U.S. Customs and Border Agency Web site at www.cbp.gov.

Medical Insurance

In case of a medical emergency, visitors in Canada have to pay for medical costs up front and then submit paperwork for reimbursement through their own insurance company.

Banking and Currency Exchange

Most places accept major credit cards. For cash on hand, use your checking, savings, or debit card and withdraw money from any Canadian bank ATM. A withdrawal fee is applied, and the money is automatically converted to the current exchange rate. For credit card-based debit cards, the issuing credit card (Master-Card or Visa) will also charge a foreign transaction fee. Avoid airport and private currency exchange counters, as you don't get the best rate. Many Canadian hotels and restaurants accept United States currency, but once again the exchange rate is to their advantage.

When to Visit and What to Bring

High season in Montreal and Quebec City runs from mid-May to mid-October. Casual neat attire wears well in Montreal and Quebec City. You can bring something dressy for special occasions. A light jacket for cool summer nights, a good pair of sneakers, and a portable umbrella all come in handy. In winter, bring long johns, thick socks, long-sleeve T-shirts, gloves, boots, hats, scarves, and the warmest coat you've got!

Travel to and from Montreal and Quebec City: By Car, Train, Air, Boat, and Bus

By car, Autoroutes (highway) 20 and 40 are the two quickest options. Autoroute 20 runs south of the St. Lawrence River. It's most easily accessed by taking the Jacques Cartier Bridge in Montreal, to 132/20 East, to Highway 20 East.

Autoroute 40 hugs the north shore of the St. Lawrence River. Travel time is a bit longer than Highway 20, but the scenery is nicer in parts, as you can actually see the river for a short clip. Traffic in the Montreal section of Highway 40, also known as the Metropolitan or the Met, can be incredibly busy. Travel time on either highway takes about three hours.

VIA Rail offers daily departures between Montreal and Quebec City. If you're not photographing any side trips, it's the worry-free way to go. The Montreal and Quebec City train stations are conveniently located as well— Montreal's is downtown, and Quebec City's station is in the Old Port. The trip takes about three hours. Roundtrip discounted prices go as low as about $100 (Canadian funds). Visit www.viarail.ca or call 1-888-842-7245.

Air Canada's Tango brand offers direct air service between Montreal and Quebec City.

That said, the train is cheaper and almost as fast when factoring in typical check-in and screening time. In addition, the train is more convenient in terms of station location versus airport location in either city. Visit www.air canada.com or call 1-888-247-2262.

Croisières Évasion Plus offers summertime Montreal-to-Quebec City St. Lawrence River cruise service that costs about $120 one-way. The cruise takes six hours and offers scenic maritime photo ops along the way. Call 514-364-5333 or visit www.evasionplus.com.

Orléans Express offers bus transportation between Montreal and Quebec City. Call 514-999-3977 or visit www.orleansexpress.com.

Language

French is indeed the official language of Quebec. Many residents are bilingual, especially those who work in the travel industry. Brush up on your high school French, as a little French on your part goes a long way.

Tourism Offices

In Montreal

Tourist info such as brochures, maps, and pamphlets can be had year-round at the Infotourist Centre at 1255 Rue Peel. Call 514-873-2015.

St. Lawrence Seaway

The Tourist Welcome Office in Old Montreal at 174 Rue Notre Dame Est is open daily from April to the beginning of November; and Wednesday to Sunday during winter.

In Quebec City

Quebec City Tourism has maps, brochures, museum cards, and more at 12 Rue Ste-Anne across from the Château Frontenac.

Useful Telephone Numbers and Web Sites

Canada and Quebec Province

Bonjour Quebec: Provides provincial tourism information. Call 1-877-266-5687 or visit www.bonjourquebec.com.
Sépaq: 1-800-665-6527 or www.sepaq.com.
Government of Canada: www.canada.gc.ca.
National Historic Sites of Canada: www.pc.gc.ca.

Montreal

Tourism Montreal: www.tourism-montreal.org.
Montreal Plus: www.montrealplus.ca.
The City of Montreal: www.ville.montreal.qc.ca.
Montreal Webcam Network: www.montrealcam.com.

Quebec City

Quebec City Tourism: www.quebecregion.com.
Quebec Plus: www.quebecplus.com.
City of Quebec: www.ville.quebec.qc.ca.
Petit Champlain Quarter: www.quartierpetitchamplain.com.
Quebec City Museums: www.museocapitale.qc.ca.

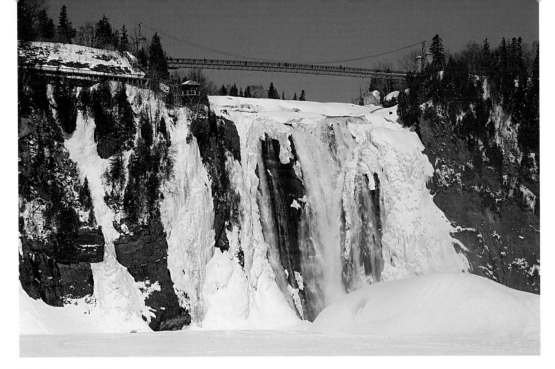

Montmorency Falls

Favorites

Here are a few places that inspire me when camera is in hand.

Landmarks and Attractions

Montreal Biosphere
Olympic Stadium, Montreal
Exporail, St. Constant, QC
La Citadelle, Quebec City
Montmorency Falls, near Quebec City

Greenery and Scenery

Île d'Orléans, near Quebec City
Jacques-Cartier National Park, near Quebec
 City
Cap Tourmente National Wildlife Area, near
 Quebec City
Montreal Botanical Garden
Mont Orford National Park, Eastern Town-
 ships

Churches

Notre-Dame de Québec Basilica-Cathedral,
 Quebec City
Grand Seminary, Quebec City
Ste. Anne de Beaupré Shrine, Beaupré, QC
St. Joseph's Oratory, Montreal
Notre-Dame Basilica, Montreal

Views

The Montreal skyline from the Man belvedere,
 Jean Drapeau Park
The Montreal skyline from the Lévis Tower,
 Jean Drapeau Park
Old Montreal views from the Clock Tower in
 the Old Port of Montreal
The Quebec City skyline from the Old Port
 Louise Marina

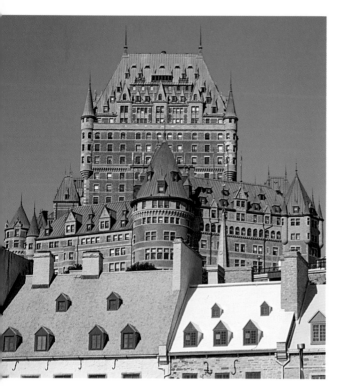

Château Frontenac from Lower Town

The Quebec City skyline from the Quebec to
 Lévis ferry
Sculptures and Public Art
La Joute, Montreal
Tourny Fountain, Quebec City
Man/Cultural Circuit, Jean Drapeau Park,
 Montreal
Parc René-Lévesque/Parc des Riverains,
 Lachine, QC

Buildings

Château Frontenac, Quebec City
Quebec City Old Port and Old Quebec
 residences and rooftops
Parliament Building, Quebec City
Bonsecours Market, Montreal
City Hall, Montreal
Train Station, Quebec City

Sun Life Building, Montreal
Le 1250 Boulevard René-Lévesque Building,
 Montreal
Customs Building, Old Montreal
Habitat 67, Montreal

Streets and Strolls

Rue Couillard, Quebec City
Rue St. Paul, Quebec City
St. Jean Neighborhood, Quebec City
Okay, pick *any* Old Quebec or Old Port street!
Rue St-Jacques, Old Montreal

Special Events

International Balloon Festival of St-Jean-sur-
 Richelieu, St. Jean, QC
New France Festival (for the costumes),
 Quebec City
Just for Laughs Festival (for the buskers and
 night parades), Montreal

Favorite Eats

AIX Cuisine, Montreal
Pierre du Calvet, Montreal (for Sunday
 brunch)
Renoir, Montreal
Cluny ArtBar (for lunch), Montreal
Les Copains d'Abord (a small café for pastries,
 snacks, and take-out lunch), Montreal
Bistro Les Bossus, St-Roch, Quebec City
Le Patriarche, Quebec City
Le Café du Monde, Quebec City
Toast!, Quebec City
Laurie Raphael, Quebec City

Extras—Favorite Stays

Sir Montcalm B&B, Montreal
Hotel Place d'Armes, Montreal
Hotel Port-Royal, Quebec City
Château Frontenac, Quebec City (it's all about
 the history)